IMAGES
of England

AROUND
TEWKESBURY

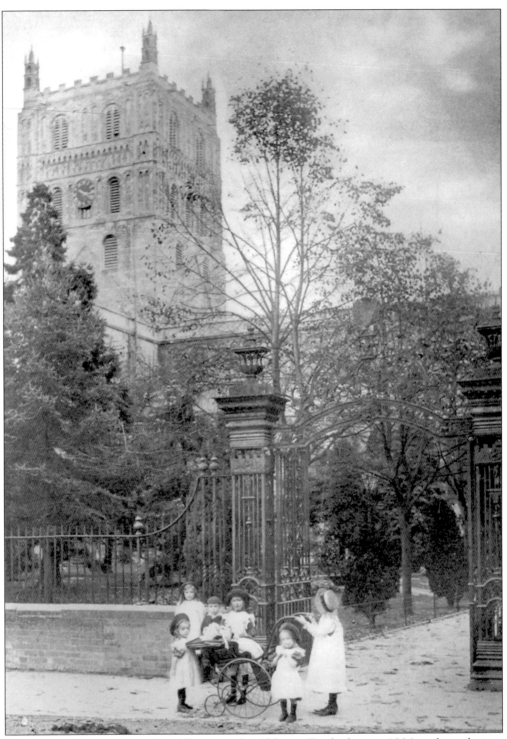

Frontispiece from the book *The Idyllic Avon:* the Abbey at Tewkesbury in 1906, with its glorious Norman tower rising in the background. This is Edwardian England, peaceful and slow moving, at the beginning of a new century.

IMAGES
of England

AROUND TEWKESBURY

Compiled by
Cliff Burd

TEMPUS

First published 2001, Reprinted 2003
Copyright © Cliff Burd, 2001

Tempus Publishing Limited
The Mill, Brimscombe Port,
Stroud, Gloucestershire, GL5 2QG
www.tempus-publishing.com

ISBN 0 7524 2273 1

Typesetting and origination by
Tempus Publishing Limited
Printed in Great Britain by
Midway Colour Print, Wiltshire

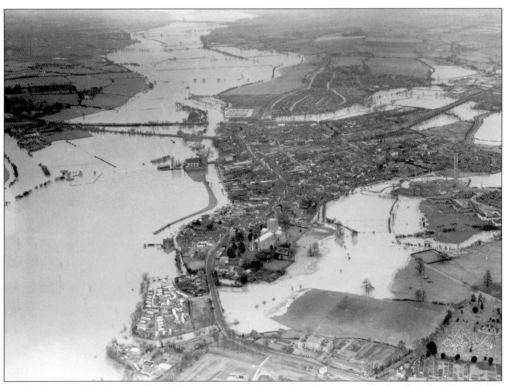

Tewkesbury in flood time; the abbey appears to be isolated on a small island. The line of the River Avon can be seen at the top of the page and the Severn bends out on the left-hand side. This photograph shows clearly why the town developed as it did, being in the centre of a flood plain.

Contents

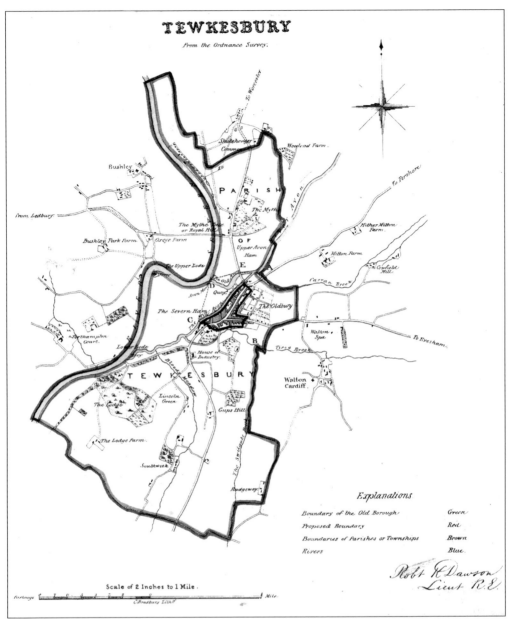

A map of Tewkesbury dated 1831, and produced by Lt Robert K. Dawson. It was drawn as part of a survey of the town and shows the boundaries of both the original parish and the borough. It was part of a national survey and the accompanying report gave details of the population, number of houses, etc.

Introduction

Tewkesbury is a market town situated where the Rivers Severn and Avon meet. The great Norman Abbey, with its massive tower, said to be the finest in all England, dominates the town. The Norman phase of the Abbey was begun in the eleventh century and completed around 1121. Its enormous cylindrical pillars, similar to those in Gloucester Cathedral, are the loftiest in the country, and the west front has its magnificent Norman arch of six orders, though there were originally seven.

There is substantial evidence of the Roman occupation of Tewkesbury from the various artefacts recovered during excavations in several areas of the town.

The Manor of Tewkesbury, which was referred to in the Domesday Book as one of the largest recorded, was purchased by the Corporation from James I in 1609, and its importance is reflected in the fact that, until 1868, it was entitled to return two MPs to Westminster.

The town has been visited by war and strife; in May 1471 the decisive battle of the Wars of the Roses was fought here. Edward, Prince of Wales, was taken and killed here together with many of his nobles. With him the Lancastrian cause also died.

During the Civil War the town was occupied first by one side and then by another, the local population having to bear the cost of these visitations. After the Civil War, the town prospered as a trading centre, with its main traffic along the rivers. It was also a popular staging post, with as many as thirty coaches stopping here on their way to the Midlands and Wales.

Tewkesbury has seen many industries come and go. Early records show that amongst others there were Guilds of Tailors, Cordwainers and Haberdashers as early as the fourteenth century.

Fortunately for today's generations, the Industrial Revolution passed us by, with the railway running from Cheltenham to Birmingham just a few miles outside the town. An attempt was made to popularize the place by following the example of Cheltenham and opening a spa. This never really got off the ground, however, and the project died.

Stocking frame knitting, tanning and nailmaking were the major industries during the 1800s, but modern machinery overtook these trades, with the last stocking factory closing in 1857 and moving to Nottingham.

Tewkesbury seemed to stand still between the two wars, for which we should all be grateful, as all the beautiful half-timbered buildings still standing have remained with us and a substantial number of the alleyways have been preserved.

Now a great deal of light industry can be found on the many industrial estates, and the M5 motorway has created a distribution centre here.

In 1971 Tewkesbury celebrated the 850th anniversary of the consecration of the Abbey and the 500th anniversary of the Battle of Tewkesbury with a festival lasting all summer. The Queen distributed the Maundy money at the Abbey and the town overflowed with visitors from all over the world.

Tewkesbury is still a popular destination for tourists with the two rivers, its museums and the Abbey, all providing something for all ages.

John Dixon
President of Tewkesbury Historical Society

Acknowledgements

My thanks are due to John Dixon for the Introduction to this book, and to Nick Burd for his help in selecting and collating the photographs and captions. For their kindness in allowing me access and use of their material a special thank you to: Chris from collections in Barton Street, Kath Hall, Alison Yaxley, Barry Sweet, Derek Round, Mike Parry, David Willavoys, Mrs Matty, Mrs Westray, Tewkesbury Museum and to Brian Linnel for the information on the alleys and courts in the town.

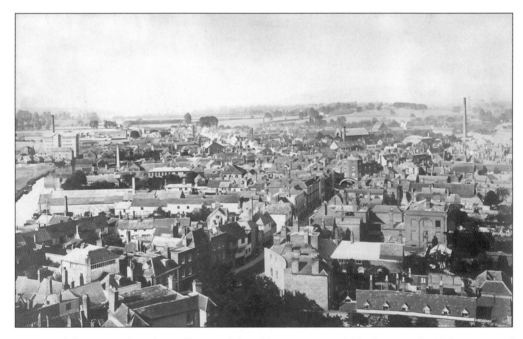

A view of the town taken from the top of the abbey tower in 1887, showing the Y formation of the three main streets. It is possible to count at least seven factory chimneys, indicating the level of industry which was located in the town.

One
The Abbey

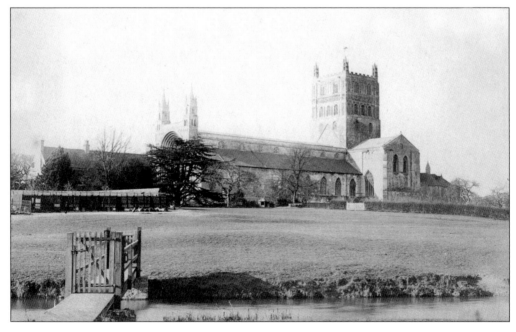

Tewkesbury Abbey as seen from the Vineyards across the Swilgate Brook, c. 1875. It is doubtful if any of the older residents will remember this footbridge across the brook which has long since been removed.

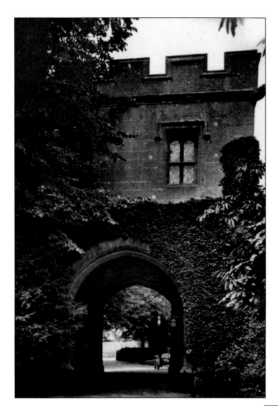

Abbey Gateway. This is the side entrance leading to Abbey House, the residence of the vicar, 1917. Over the years it has had many uses, including as a Sunday school and as an early grammar school based on the Abbey.

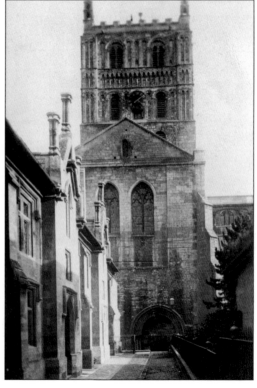

The buildings on the left are Russell's Almshouses, rebuilt from the originals in 1831, with a Gothic ashlar front. Adjacent to this site stood the old Bell Tower, which eventually became the town gaol, and was demolished to make way for a school building.

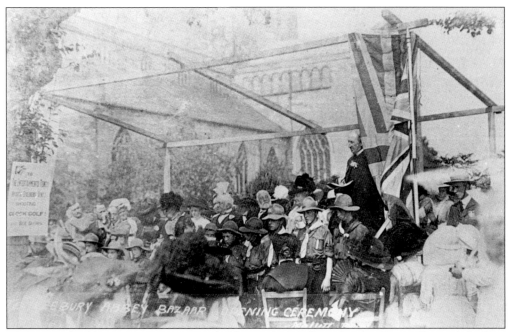

The Annual Abbey Bazaar or Fête, probably in 1916. Judging by the Union flag and the Boy Scouts in uniform this was most likely a fund-raiser for the boys at the front.

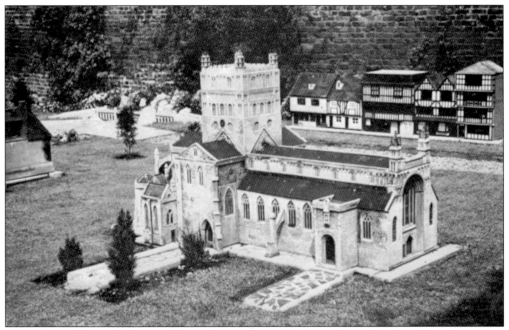

During the 1950s, the Town Council purchased this model of Tewkesbury. It is seen here laid out in the gardens of the Town Hall in 1960 and was a tourist attraction throughout the 1960s and 1970s. It is now preserved in the museum in Barton Street.

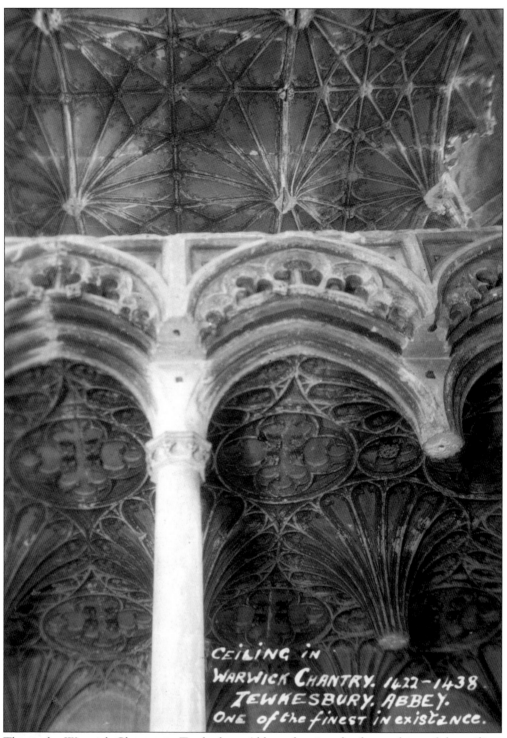

CEILING IN
WARWICK CHANTRY. 1422-1438
TEWKESBURY. ABBEY.
ONE of the finest in existence.

This is the Warwick Chantry in Tewkesbury Abbey, showing the fan vaulting of the ceiling, reputed to be some of the finest in the country. The picture was taken in 1920, but the view has remained unchanged for several hundred years.

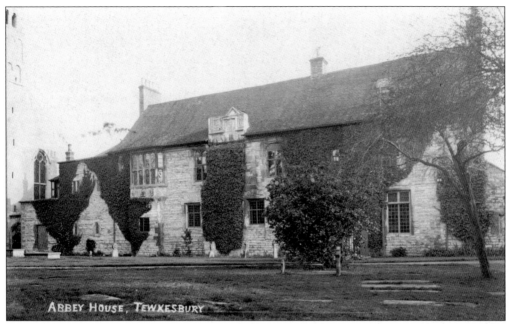

Abbey House was part of the Abbey estate that was sold off around 1900. At the end of the nineteenth century, this property, together with land at the rear of the Abbey, was bought and restored to the Abbey. It is now the residence of the incumbent of Tewkesbury Abbey. Note the oriel window.

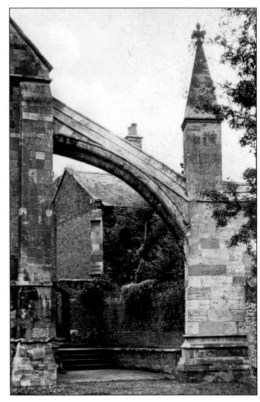

A view in 1930 of a flying buttress at Tewkesbury Abbey. This architectural device supports the building at the northern sidewall of the Abbey.

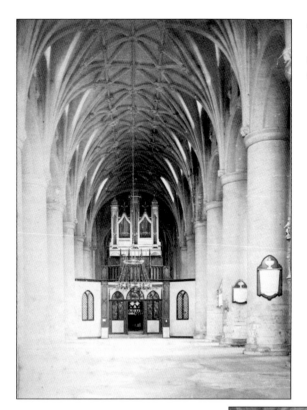

This is the nave of the Abbey around 1874, showing the organ and the screen at the west end, before the changes took place.

Thomas Collins, a local builder, undertook the restoration of the Abbey in the late nineteenth century. In 1875, the pews, pulpit and organ were removed. This shows the Abbey Choir just before that took place around 1874. All the box pews shown here were removed, together with the old pulpit on the left against the pillar.

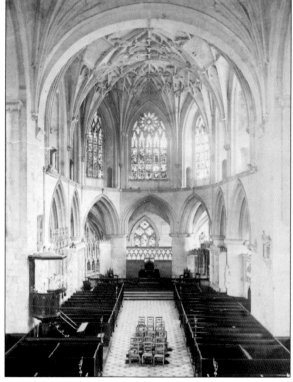

Two
The Rivers

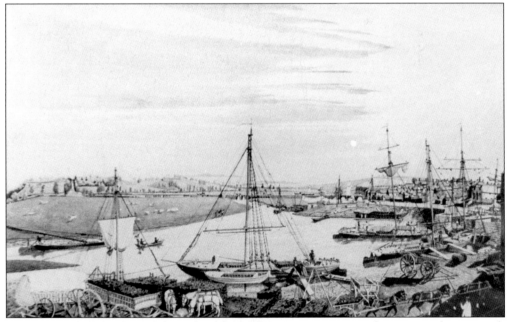

Taken from a watercolour of the early eighteenth century, activity at the quay can be seen with the Severn trows loading and unloading and the wagons taking off coal and other goods for delivery around the town.

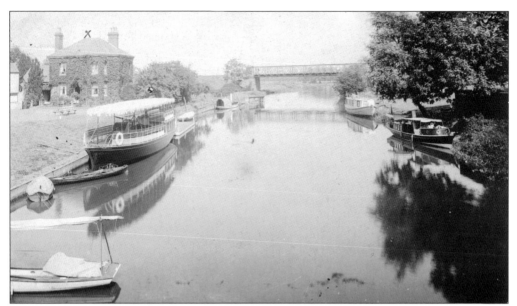

Bathurst's boatyard in 1907 where two large steamers are moored up. The punt on the left has a canvas sun canopy, just the job for a lazy Edwardian day on the river. Rowing boats, and later, motor-boats, could be hired by the hour or the day, by those looking for a quiet day on the water.

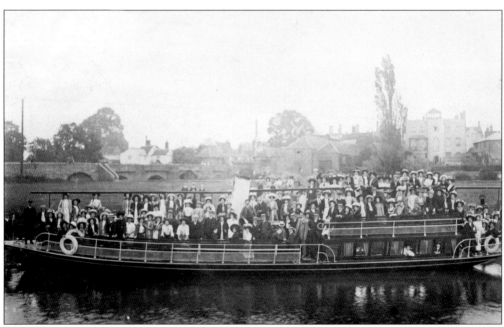

The boat builder Bathurst owned both the *River King* and the *River Queen*, pleasure boats which took individuals and parties up and down the river. This group, photographed in 1919, was probably a Mothers Union or a WI outing.

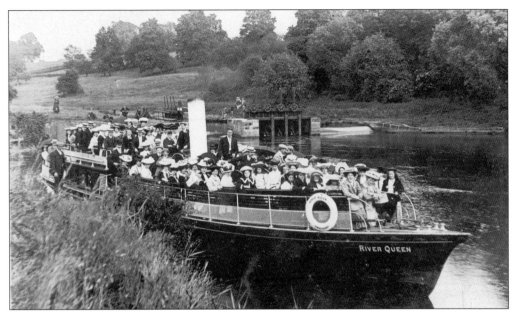

The *River Queen* once again in 1919. Is this the end of the journey for the passengers in the previous picture? In the background is a lock with the bank rising up from the river, most likely at Nafford near Eckington.

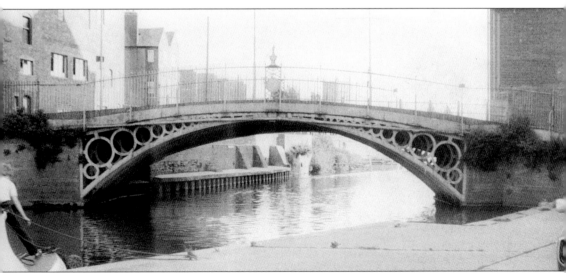

This bridge replaced the old sandstone bridge at Quay Street in 1822. It provides access to the Borough Mills on the right, and the old quay and landing stage beyond, where the barges loaded and unloaded their goods.

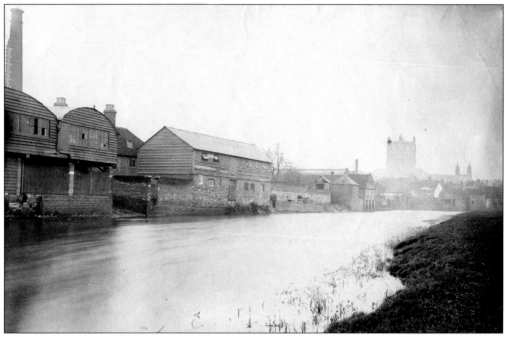

The factory buildings which backed onto the River Avon, c. 1900. The river is almost up to the top of the banks; the bank on the Ham side was not raised until around 1934, when the river was dredged. On the left the factory chimney for the Eagle factory can be seen.

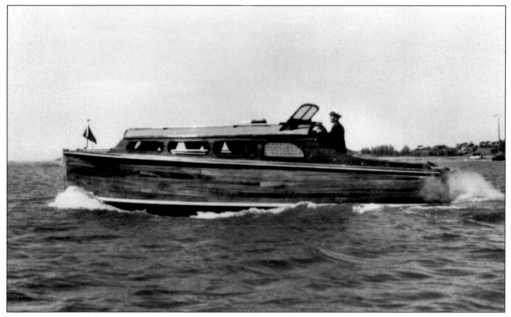

This is 1936, and Leo Robinson, who operated from the same site as Bathurst had done since the late 1800s, built the *Silver Snipe* at Tewkesbury. During the war, Motor torpedo boats were built here and shipped down the river to be commissioned by the Admiralty.

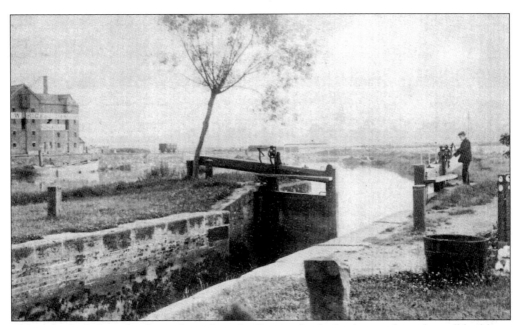

This is the lock from the Avon through to the Severn. In the background are the mill buildings of Mr Rice, demolished in the mid-1950s. A lone railway wagon sits beside the quay. The railway ran down to the quay from the station and across the main road.

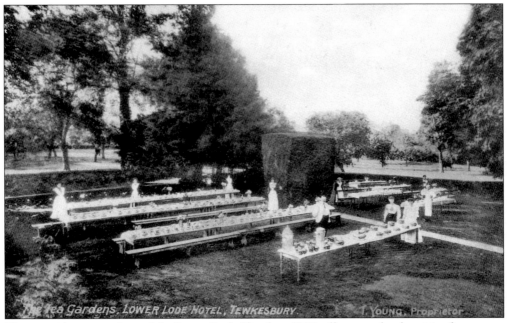

These are the tea gardens of the Lower Lode Hotel, c. 1910, all set out for the visit of a steamer and its passengers. The hotel catered for campers as well, and was responsible for the operation of the ferry across the river.

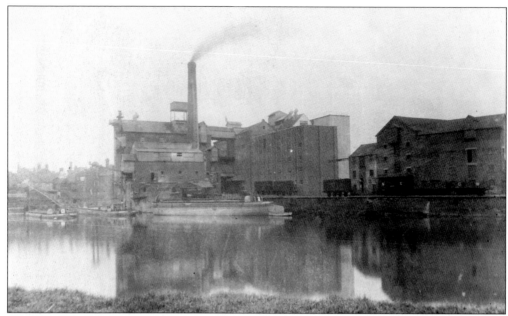

The Borough Mills stand across the Mill Avon on the Ham field, 1935. Built in 1865, these mills have been in work continuously since, producing flour for both local and national consumption. The railway used to run from the station in the town, across the road and down to the mill and the quay; note the carriage. The barge is one of the many which would have serviced the mill, trading from Bristol and Gloucester.

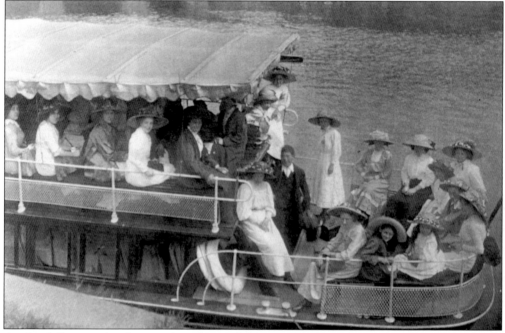

A splendidly attired gathering aboard one of the river steamers, in 1912. This is an excursion for the Abbey Sunday School teachers and the group was heading for Bewdley – quite a trip for one day.

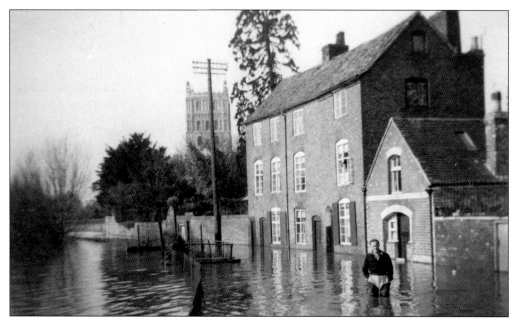

Swilgate road runs parallel with Church Street and along the bank of the Swilgate Brook. The whole of the town, including Church Street, was flooded in 1947. Mr Horace Key, standing up to his knees in the flood, has just been helping to evacuate some of the residents in the houses behind him.

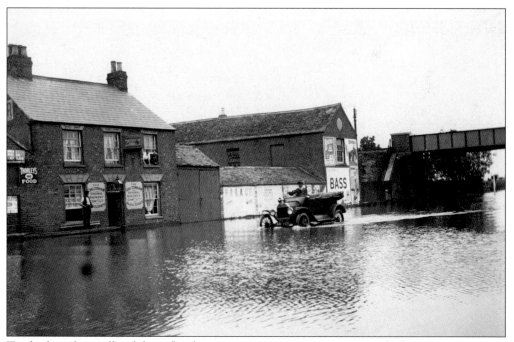

Tewkesbury has suffered from flooding every winter, sometimes upward of six or seven times. The flood of 1924 came in June however, and virtually cut off the town. This is the White Bear at the junction of Bredon Road, with the landlord, Harry Jones standing on a box outside the pub, whilst an adventurous driver tries to get through.

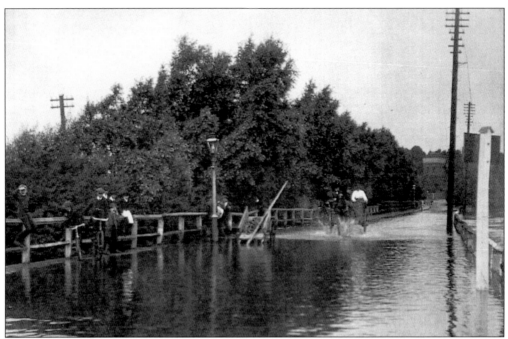

The horse and carriage has no difficulty getting along the Mythe Road, during the flood of 1912. The lads sitting on the fence, however, are waiting for some sporting motorist to come along and give it a try.

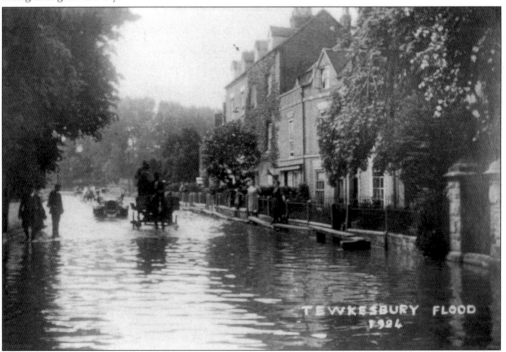

The June flood of 1924 inundated the town. This is Abbey Terrace, where the inhabitants set up a series of planks to walk on, outside the gates. This is a scene which has been repeated many times, but not in high summer! All the roads into the town were flooded.

Three
The Town

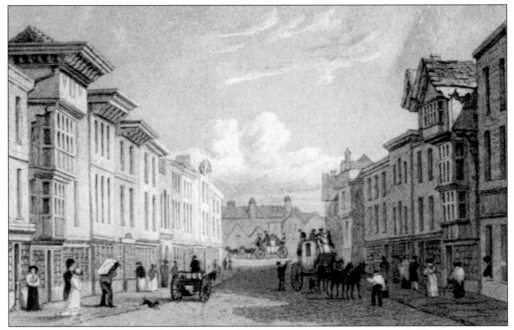

One of the earliest prints of the town, dated before 1800, where we see the High Street looking towards the Cross. The coach is waiting outside the Nodding Gables, then a ticket office. This was a time when upwards of thirty coaches a day passed through the town.

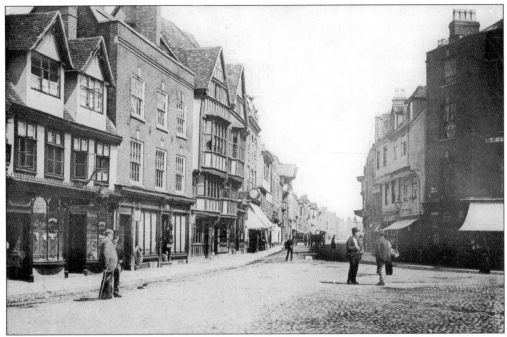

The junction of the three main streets, *c.* 1900. This is sight which shall not be seen again – people standing in the road chatting! The streets have not yet been macadamized, and are still cobbles, which was the usual street surface for many years.

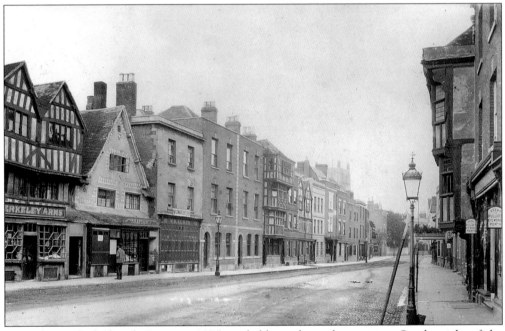

The other end of Church Street in 1875, probably in the early morning. On the right of the picture the local lamplighter is out and about and probably doing a spot of maintenance. Barsantis shop on the left of the picture has not yet had its half-timbered frontage exposed, and the street still has its cobbled surface.

The High Street looking northwards, *c.* 1920. There is still not much traffic about, just a few open-topped cars, but the street lighting is now electric. The large key hanging from the Nodding Gables is one of the few street advertising signs still remaining in the town.

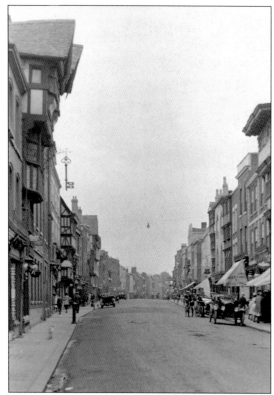

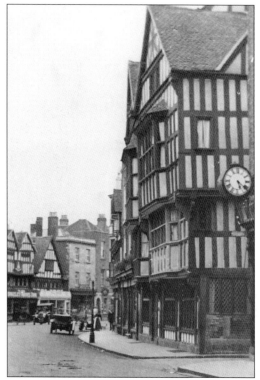

Cross House in 1910. This half-timbered building was reputed to be the site of the earl's court, but at this time is was the residence of Thomas Collins, the local builder. In 1886 Alderman Smart donated to the town the clock which is fixed to the building. The gas lamps on the pavement appear to have been dismantled and electric lighting has been strung across the road.

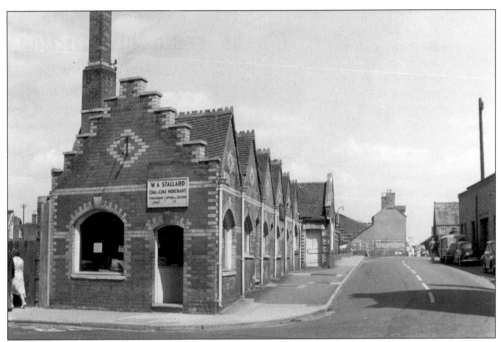

This is the old line of Station Street in 1965. The shop on the front, which has the firm of Stallard's in occupation, was for many years a bespoke tailor. Along the left hand side of the street was a series of small shop units – a barber, cobbler and others. On the opposite side is the workshop of the Tewkesbury Car Mart. In the centre rear of the picture stands the Railway Inn, with Warner's Garage behind.

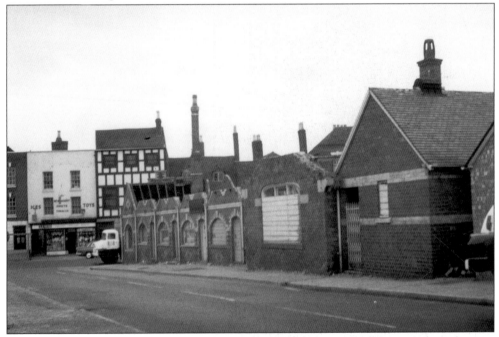

Station Street looking toward the High Street in 1965. The row of buildings on the right were individual units. Shortly after this date, Station Street disappeared.

An auction was held at the Sun Inn on 12 August 1790. The Sun Inn was at the corner of High Street and Sun Alley, but has long been demolished along with the Alley bearing its name.

AUGUST, 12th, 1790.

To be Sold by Auction,

By MOORE and EDGCUMBE,

At the *SUN-INN*, TEWKESBURY,

On Thurſday the 19th of Auguſt, Inſtant,

Between the Hours of 2 and 4 in the Afternoon, according to ſuch Conditions of Sale as ſhall be then and there produced,

(Unleſs diſpoſed of, in the mean Time, by Private Contract, of which due Notice will be given)

ALL THAT NEWLY ERECTED

Meſſuage or Tenement,

WITH THE

STABLE, GARDEN, and APPURTENANCES,

Thereunto adjoining and belonging;

ALSO

A TENEMENT behind the Same,

Situate in the *BARTON-STREET*, in *Tewkesbury*, aforeſaid;

Late in the poſſeſſion of Mr. PETER PARKINGTON, deceaſed; but now of Mr. WILLIAM JEYNES, Yearly Tenant.

For a View of the Premiſes, apply to Mr. Parkington, at Mr. Griffiths's, in the Barton-Street; and for other Particulars, or to treat by Private Contract, application may be made to Mr. Stephens, Attorney, Tewkeſbury, or the Auctioneers.

WILTON, PRINTER.

The Nodding Gables was a coaching ticket office for many years, but seen here in 1870 it was an ironmongers, a trade that occupied the shop for the next hundred years.

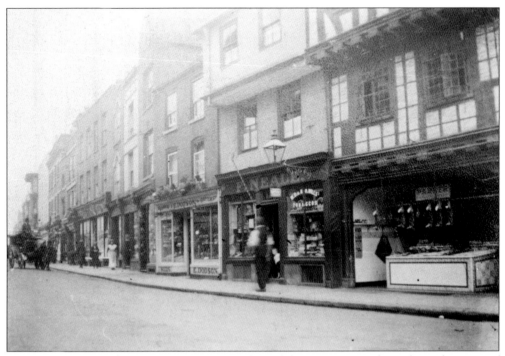

The High Street looking from the Cross. Parker's fishmonger is on the right with a row of rabbits on display for sale, around 1890. The coach coming down the street is probably from the Swan Hotel, from which it ferried its patrons to the railway station.

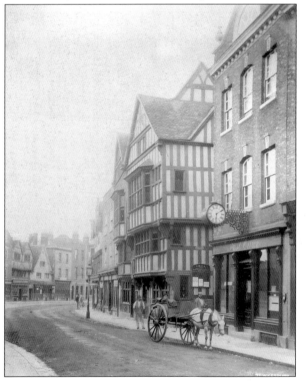

This is the High Street looking towards Church Street. On the right hand side is the post office, as it was around 1890, with the clock, presented to the town by Alderman Smart, above it. The post office has been moved around the town on many occasions, from the High Street to Church Street and back to two locations in the High Street. The notice board on the wall in the background is for the YMCA, which was located in Tolsey Lane before moving to its present site.

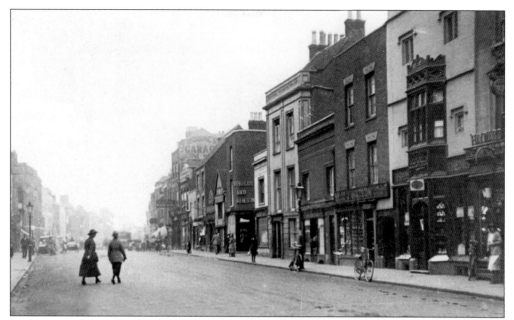

Looking north, up the High Street, *c.* 1920. It was still possible for cyclists to leave their machines in the street without fear of losing them. Osborne's Garage provided fuel directly onto the main street for the increasing motor trade.

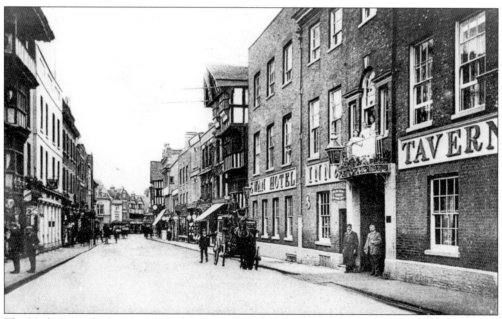

The High Street looking towards the Cross, *c.* 1900. The Swan Hotel coach, horse drawn, waits outside with its top-hatted driver aboard. The manager, Mr Hopkins, stands at the entrance, keeping an eye on things. The balcony above the entrance was used to declare the results of local and national elections.

This view, taken around 1930, was the view from Bathurst's the boat builder, across the Avon. Called Twixt Bears because it lies between the Black Bear and the White Bear pubs, this was a large private residence, demolished around 1960 to allow the site to be developed with several blocks of flats.

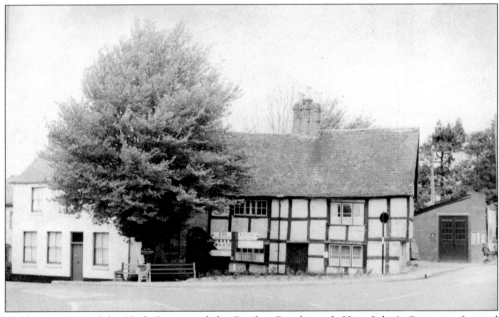

At the junction of the High Street and the Bredon Road stands King John's Cottages, fronted by a large elm tree. These are sixteenth and seventeenth-century buildings, which run down to the water's edge on an old public slipway. It was here, under the tree, that the town stocks were sited which were used to punishr minor crimes such as vagrancy.

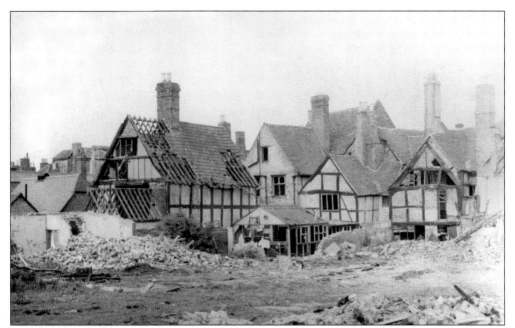

The rear of the High Street in 1965 gives some indication of the devastation that took place. The whole area was cleared, with little or no thought for preservation.

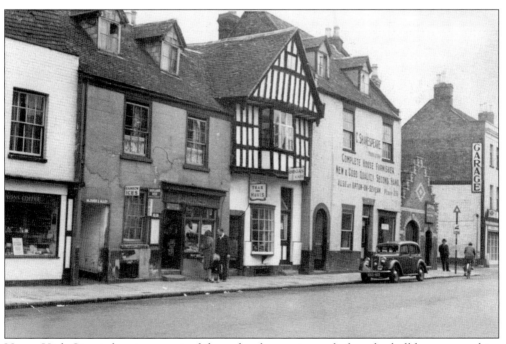

Upper High Street showing a part of the redevelopment area before the bulldozers moved in, c. 1965. This building was the Doddo Café, with, to the left, Nellie Jones' shop. On the right is Mr Shakespeare's antique furniture shop. This view shows entrances to at least three alleys or courts in this area which have now disappeared.

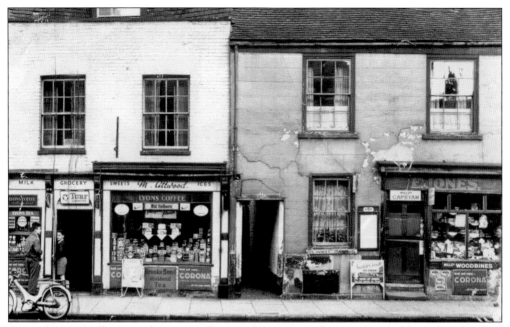

Around 1960 Nellie Jones kept a small general store next door to the Doddo Café. The shop was popular with children as it boasted one of the first ice cream making machines in the town. Children were allowed to turn the handle of this machine for fifteen minutes, and in return would get a free cornet!

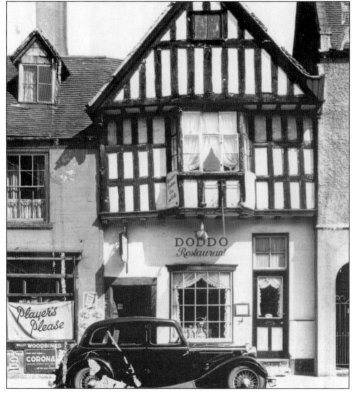

The Doddo Café, at the top end of the High Street, was a meeting place for the ladies of the town for morning coffee or afternoon tea. This beautiful half-timbered building, which had a large studded door is thought to have come originally from the Abbey, was swept away in the late 1960s, falling prey to the re-development of the upper High Street, together with many other early buildings.

Gander Lane leads from Church Street to the Vineyards. This view, around 1950, shows Richardson's Almshouses on the left. They were originally built in the seventeenth century, but were demolished in 1965 and rebuilt as four modern almshouses on the same site.

Barton Street. The Nelson Inn stood on the corner of Barton Street and Nelson Street, the name obviously dating from around 1800. The pub was closed in 1970.

The two buildings between the Ivy Leaf Café, and the Nelson Inn, have also disappeared from this area of Barton Street. The shop on the right was a bookshop and a framers run by Mrs Howells, MBE, a founder of the Civic Society. They were demolished just after this picture was taken in 1970.

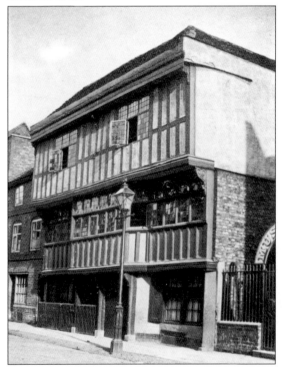

A sixteenth-century merchant's house when it was built, and still a dwelling house here in 1870, this building was purchased anonymously for the town in 1963. It was to be used as a museum reflecting the life of the town. The wooden fencing on the front is original, and probably unique, and the long stretch of windows on the upper floors suggest that it could have been used for weaving or silk manufacture.

By 1839 Tewkesbury had its own police force, with a set of cells which can still be seen in the basement of the Town Hall. When the force merged with the County Police Force in 1864, a new police station was built at Bredon Road. These are the cells and the picture shows a workman dismantling a bed. Note the 'spyhole' and the 'drop window' in the door. The new station was resited in Barton Street and this one became a dentist's surgery. This photo was taken around 1960.

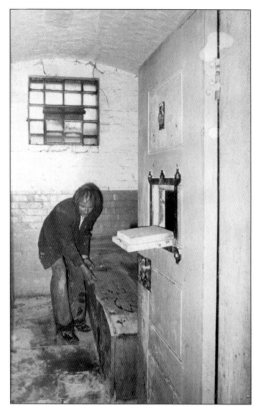

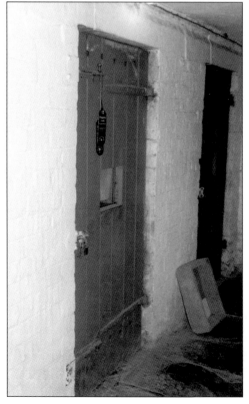

These are the old police cells situated in the basement of the Town Hall, and were used for the holding of prisoners awaiting trial or due to be sent to Gloucester prison. They were introduced in the nineteenth century, but have not been in use for the past hundred years other than for storage, as this recent picture shows.

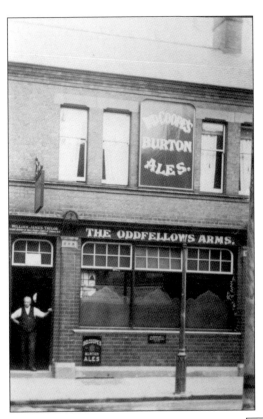

Another of the pubs which have disappeared from the streets is the Oddfellows Arms, which used to be at No. 110 High Street. The front had brown-glazed tiles and large frosted glass windows. The tenant in 1930, Mr William Taylor, is standing in the doorway, which was the passage which led to bar. The pub was closed in 1971.

The residents of the town will recognise this view of 1880 as being the Hat Shop in Church Street, as there has been a large Beadle's hat as a sign outside the shop for many years. However, in the nineteenth century, it was Osborne's Hay Warehouse. The entrance to the left of the shop is Bank Alley, so called because the building on the left was a bank during the nineteenth and twentieth centuries.

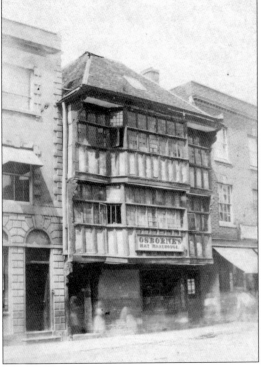

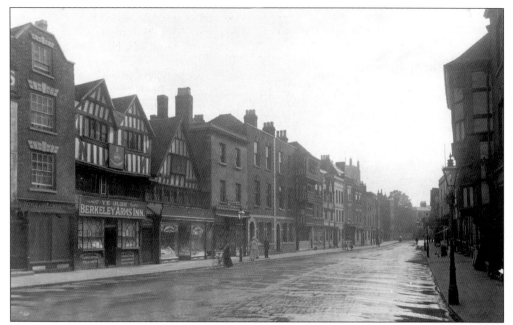

Church Street on an early morning in 1913, and the water cart has been washing the streets. The Berkeley Arms advertises 'Chops and Steaks' for its customers. Only one cycle is to be seen, no heavy vehicles and no street furniture. The gas lamps are still in evidence, all fairly tranquil with the great conflict of 1914 only a year away.

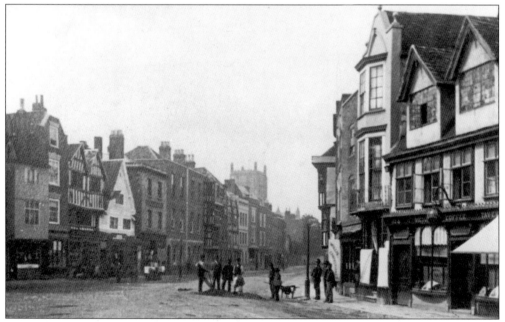

The Cross, Church Street, looking to the Abbey in 1870, with a group of council workmen repairing the road. The white building on the left, next to the Berkeley Arms, had its frontage stripped to reveal the timber structure a few years later.

Gander Lane runs from The Crescent to the Vineyards. Edward Richardson originally built the Almshouses on the left in 1651. In the mid 1960s, seen here, they were closed and then demolished and rebuilt with all mod cons.

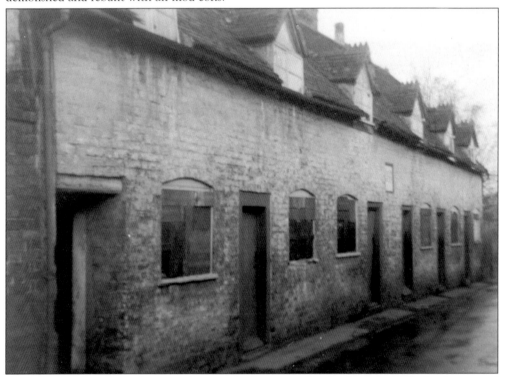

Edward Richardson built this row of seven almshouses in Gander Lane in 1651, for the poor of the town. They were repaired in 1739, but in 1965 as seen here they were due to be demolished and replaced by four modern cottages.

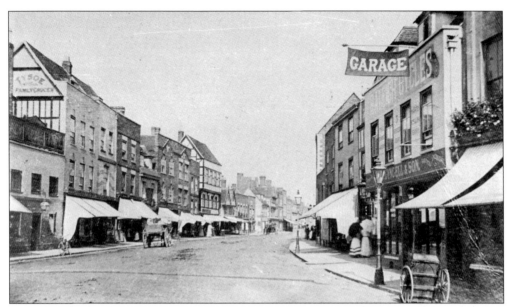

This scene looking down Barton Street in 1910 shows a quiet market town of the Edwardian era. There are no traffic problems and the horses and carts are free to use either side of the road. The buildings in general are the same, but the Tracy Arms on the left closed around 1930. Later, a petrol pump was erected next to the gas lamp on the right, to serve the new motoring trade.

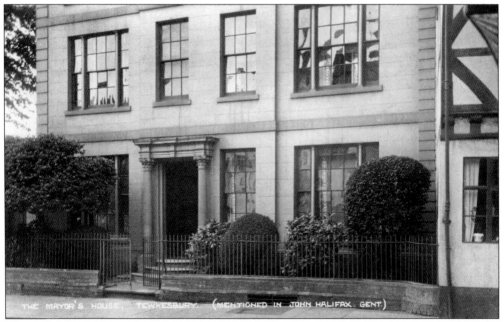

This is Crescent House in around 1930. To the right the row of medieval cottages can just be seen. The iron railings at the front were taken, along with most others, for the war effort in 1940. The house was demolished in the 1960s, when the Crescent was enlarged and another entrance, with large gates, was erected for the abbey.

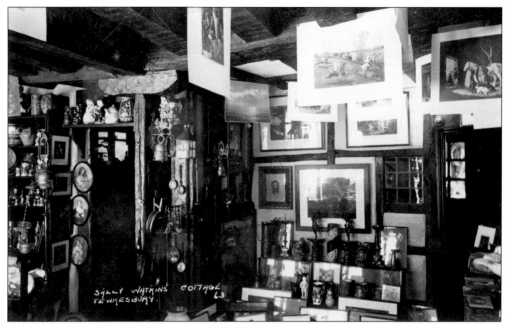

The interior of the shop, which was called 'Sally Watkins' Cottage', showing the connection with the story of John Halifax, Gentleman. As can be seen in 1920, the shop sold artists' materials, and prints and pictures of the area.

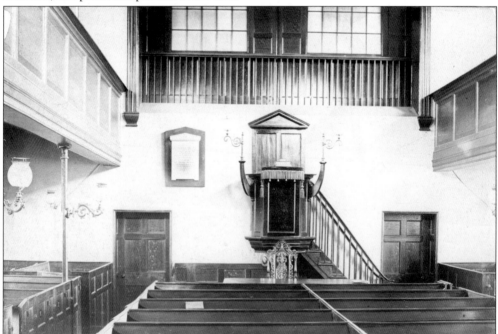

The original Baptist Chapel in Church Street was built in 1632, but by the beginning of the nineteenth century was too small for the congregation, and so a new chapel was built in 1803. This was constructed at the rear of the old Star and Garter Inn in Barton Street. The high pulpit and balconies are typical of 1900, when this photograph was taken. The box pews and the gaslights were eventually replaced, and now a new chapel has replaced this one.

Four
Sports and Clubs

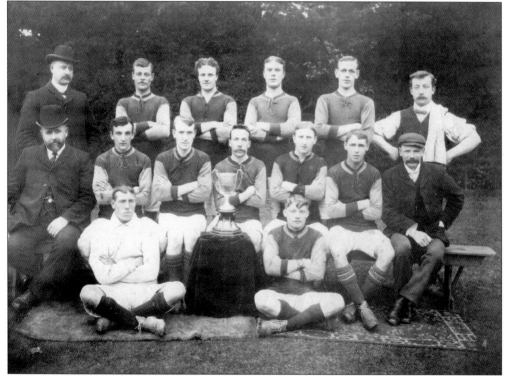

The successful football team of 1908, which won the First Division of the Cheltenham League. The names will be familiar to local people as their sons and grandsons will still be in the town. Tom Bassett (back row) fought with the Glosters in the First World War, and Mr Hopton (seated front right) had his curls until his death at an advanced age! From left to right, standing: White, T. Bassett, T. Crisp, F.J. Manning, D. Moss. Seated: H. Charles (secretary), J. Broad, H. Healey, A.J. Surl (captain), E.C. Alcock, A. Jordan, H.H. Bathurst. Front row: J. Heath, M. Hopton.

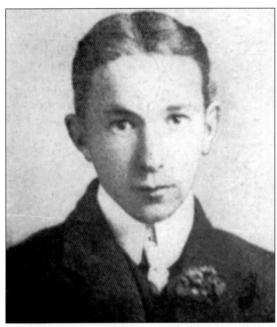

Alfie Dipper, seen here around 1912, was the son of a farmer and lived at Apperley. When he was thirteen years old he went to Tewkesbury Grammar School, where he received some coaching. Has was captain of the village side when he was sixteen, playing each Saturday. During the week he played at Tewkesbury, where he eventually came to the notice of Jessop, the captain of Gloucestershire. In his first match for the county, he made the highest score, and went on to play for England.

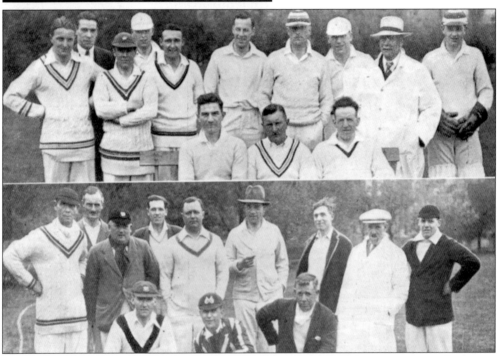

The Tewkesbury CC at this time, 1930, consisted mainly of local businessmen, as the games were mainly played mid-week and Saturdays. Most people would have been at work on those days. The captain, C.S. Barnett, was the father of Charlie Barnett, the Gloucestershire and England cricketer, who played for the town team on occasions. From left to right, standing: A.P. Barnett, G.H. Edkins, E. Stephens, W.C. Simms, C.H. Chatham, E.G. Morrison, M.S. Maxwell-Gumbleton, R.E. Green, W. Heath (umpire), W.T. Mustoe. Seated: C. Neale, C.S. Barnett (captain), H.G. Warner.

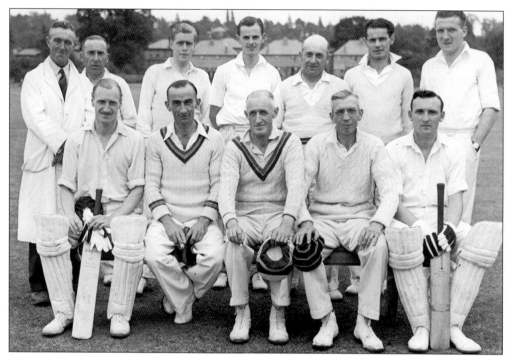

The team of 1947 shows the resurgence of the club after the war, when most of the young men who would have been playing had been on active service. Wartime saw the suspension of most sporting activities, some taking longer than others to get started again. From left to right, standing: -?-, L. Townsend, Haslock, S. Caudle, F. Nottingham, L. Bourton. Seated: N. Neal, H. Roberts, E. Neal (captain), G. Robinson, J. Bourton.

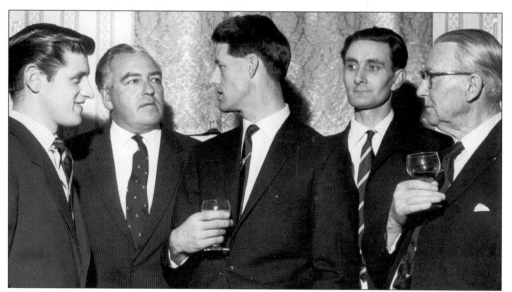

1968 Tewkesbury Cricket Club Annual Dinner at Gupshill Manor. The club had arranged a benefit match for John Mortimer and the cheque was presented at the dinner. From left to right: Geoff Haines (club captain), M. Jarrett of Lydney, John Mortimer of Gloucestershire and England, Brian Devereux (honourable secretary) and Col. A. Hattrell (club president).

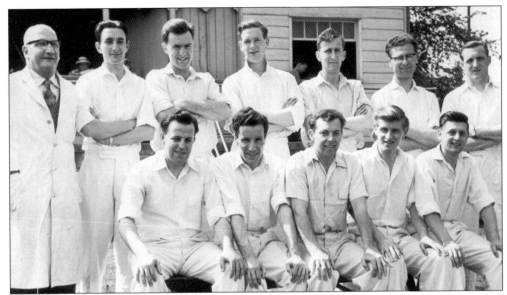

The town club in 1962, showing a much younger team than in 1947. As more clubs started playing again, the fixtures became stronger and teams travelled further afield. League cricket had not yet been introduced into the area. From left to right, standing: H. Bourton, B. Devereux, G. Page, A. Atwell, Dr G. Shepherd, T. Crisp, B. Goodwin. Seated: M. Sollis, A. Collins, C. Burd (captain), G. Haines, K. Haines.

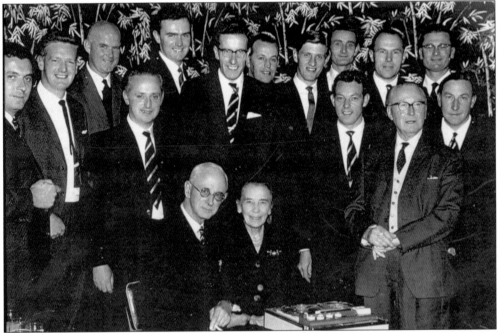

Dr Hopper Shepherd had been president, as well as chairman and benefactor, of the Cricket Club for many years. Upon his retirement, in 1967, the club held a dinner in his honour, and presented him with a tape recorder. From left to right: Bill Onions, Tony Attwell, Harold Cartwright, Gerry Sollis, Godfrey Page, Tony Collins, Maurice Sollis, Geoff Haines, Brian Devereux, Cliff Burd, Dennis Bowles, Col Hattrell, Tom Crisp and Frank Coutts.

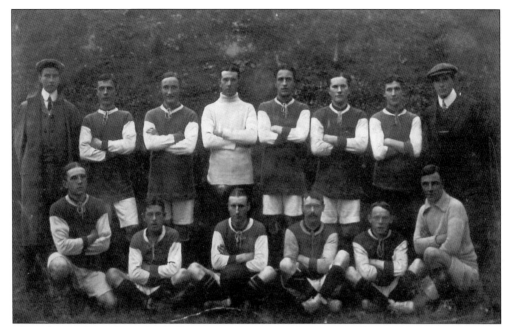

There have always been football teams in the town, this is the oddly named 'Thursday Early Closing Team'. From left to right, standing: W. Chandler, W. Mason, A. Jordan, E. Cudmore, J.V. Parsons, R. Bloxham (captain), S. Morgan, A. Williams (referee). Sitting: A. Wilkes, E. Boroughs, H. Alcock, W. Green, L. Green, W.H. Reeves.

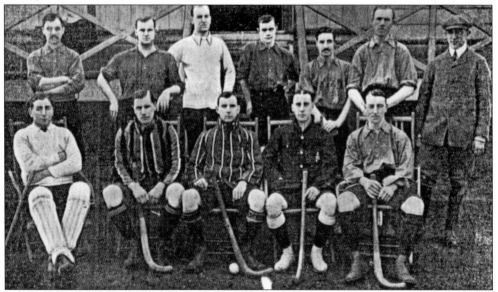

The Tewkesbury Hockey Club, seen here in 1907, was one of the sporting organizations to join the Tewkesbury Sports Club. The tennis, bowls, hockey, and cricket clubs all joined together to form this organization, which continued until the late 1930s. The hockey teams played during the winter months, providing there were no floods. The captain, on the right, has the look of a local farmer. From left to right, standing: L.E. Guilding, G.L. Potter, J. Willis, P.N. Hands, T.L. Rodway, Revd F. Langford-James, C.L. Davey (captain). Seated: A.W. Shortland, J. Butland, W.W. Jackson, H.S. Slade, C.N. Hulbert.

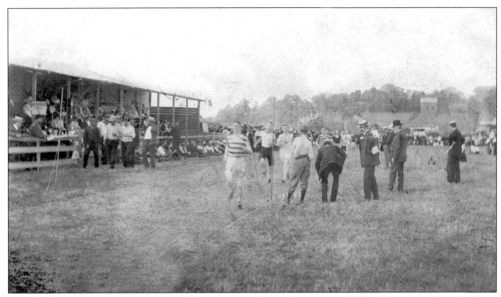

Tewkesbury Regatta was an annual event staged on the river and the Ham meadow. It drew rowing teams from all across the country for many years. Sports events were also held on the Ham, and Regatta meadows. This is the mile race in 1906. Arthur Allen is in the lead with W.H. Smith close behind; note the 'Grandstand' on the left.

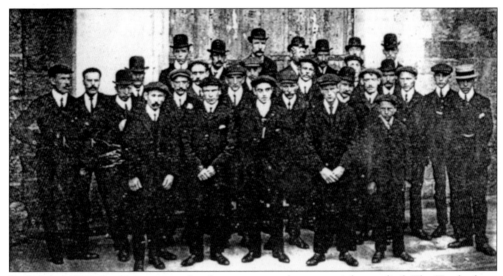

In October 1908, Fred Manning, a local sportsman and county cricketer, died. The Tewkesbury Working Men's Club attended a service at the Abbey, all dressed in traditional black. From left to right, back row: F. Reeves, A. Jones, A. Parsons, G. Jones, W.S. Moore, R. Graham, A. Day. Second row: C. Turberville, A. Bassett, W. Jordan, T. Bassett, A. Didcot, H. White, J. Fletcher. Third row: P. Moore, E. Linnell, H. Allen, J. Rice, J. Broad, C. Clements, H. Bassett, W. Hallings, J. Francis, H. Green. Front row: T. Collins, E. Dance, F. Fairbrother, F. Fletcher, W. Francis.

Five
Business and Industry

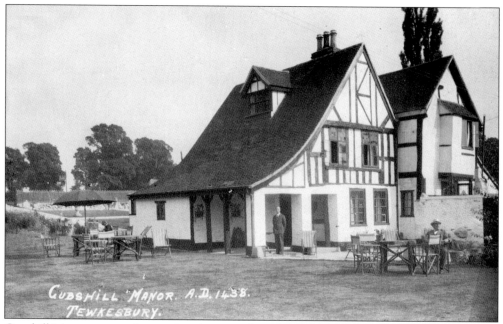

Gupshill Manor, now a thriving hotel, sits in the centre of the battlefield of 1471. Parts of the hotel date from 1438, but most of it was built in the sixteenth century. In the 1920s it suffered fire damage but was rebuilt and extended and is now a very popular family attraction, with gardens and an extensive restaurant.

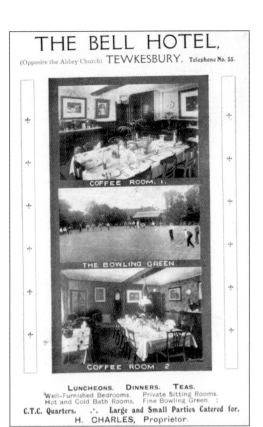

An advertisement for the Bell Hotel, Church Street, published in 1920. Originally this site would have provided hospitality and accommodation for the Abbey. To the rear of the hotel was the bowling green, said to have been used by the monks. This has now been developed as town houses.

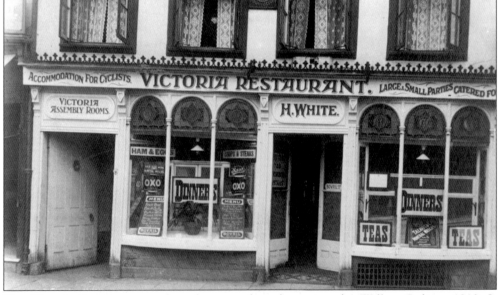

The Victoria Restaurant stood at the cross, later becoming the Willow Café, c. 1910. It provided substantial meals for the farming community when they came into town on market days. It also catered for the increasing numbers of cyclists who, in the Edwardian era enjoyed the freedom of the roads. Chops and steaks, as well as roast beef are offered on the menu. Note the Cyclists Touring Club plaque on the wall.

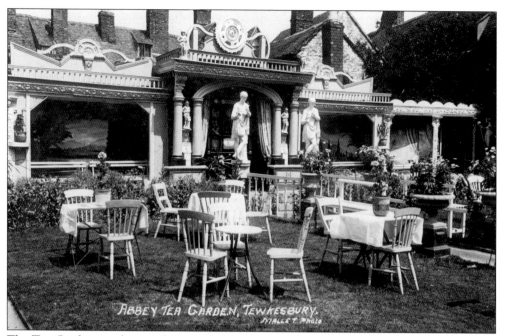

The Tea Gardens, with a parakeet on display – quite a dramatic display for a small town. One of Barsanti's statues now marks his last resting-place in Tewkesbury cemetery.

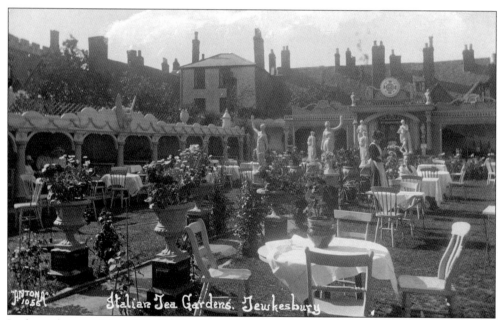

In the early part of the 1900s Palmiro Barsanti opened an Italian Tea Garden in Church Street, adjacent to the Abbey Wall. He placed quite a large quantity of statuary in the gardens, as can be seen from this picture of 1910. He sold ice cream and a large variety of confectionery for all the townspeople who were looking for good service and conversation.

In the 1930s, the rear of the Hop Pole Hotel was laid out with gardens for the residents. The stables, which were to the left of the main building, were converted into accommodation.

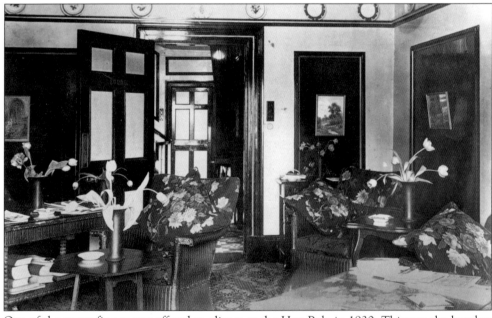

One of the many fine rooms offered to clients at the Hop Pole in 1930. This was the hotel at which Mr Pickwick and his cronies 'stopped to dine'.

Another of the hotel's comfortable rooms, 1930. This is the front lounge, with a cosy fire alight for the patrons.

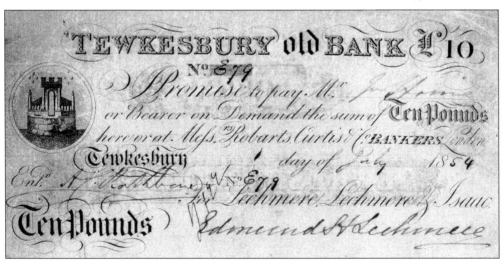

This rare banknote for the sum of £10 is dated 1854 and can now be seen in the Tewkesbury Musuem. Lechmere, Lechmere and Isaac ran Tewkesbury Old Bank and the note is made payable to Mr J. Horne and is signed by Edmund Lechemere, director of the bank.

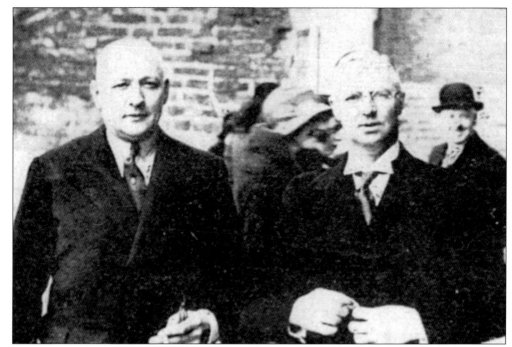

The grand opening of the Sabrina cinema in 1936, with the managing director, Harry Wright, on the left and the Mayor, councillor R.A. Gaze, a local businessman. The official opening was by The Hon. W.S. Morrison, MP for the town and Speaker of the House of Commons.

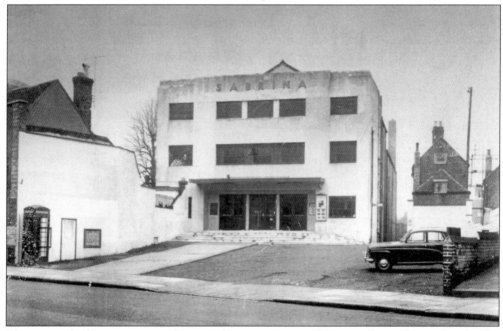

The cinema had seating on two floors, with a restaurant on the upper floor. The cinema ran for some thirty years with a change of programme every Thursday. Sunday opening saw a different film showing. Unfortunately, like many cinemas, television decreased the popularity of the cinema and it closed in 1963, as can be seen here.

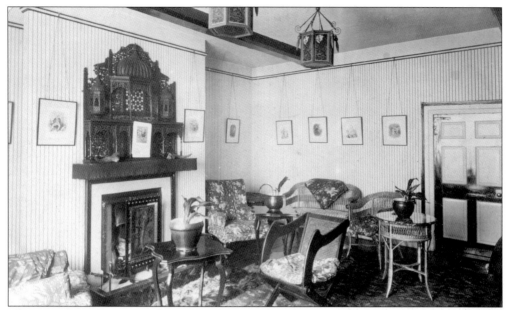

These are the well-appointed rooms of the Royal Hop Pole Hotel in Church Street. This is the Pickwick Room around 1930, and there are pictures of all the Dickens characters hung around the room.

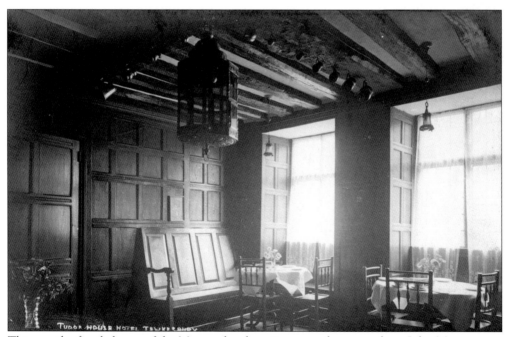

This was the family home of the Moores, local auctioneers, whose grandson, John Moore wrote the *Brensham Trilogy*. Since the house has become a hotel, the oak-panelled dining room, overlooking the High Street, has become part of the restaurant.

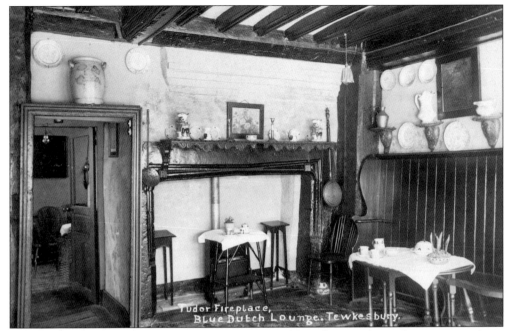

The 'Blue Dutch Lounge' in the High Street, 1910, although it was better known to residents as The Ancient Grudge. The fireplace in the main room is Tudor and has the initials 'R' on either side of it.

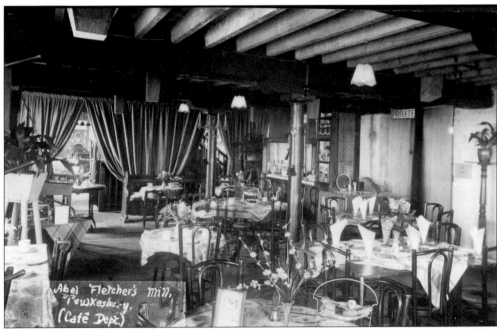

The Abbey Mill on the Avon, c. 1920. This was described in *John Halifax, Gentleman*, as Abel Fletcher's Mill. Since it ceased production of flour, it has become a restaurant, latterly holding medieval banquets.

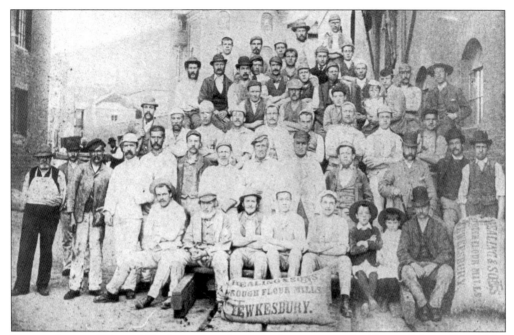

The workmen of Samuel Healing sitting between the two main buildings of the mill, *c*. 1890. The railway tracks can be seen beneath the large sack of corn and the two children at the front are probably those of the owner. The man on the right with the broad-brimmed hat is either the manager or a member of the Healing family.

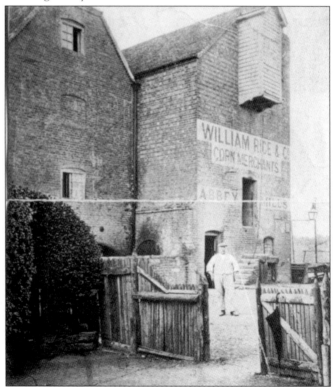

Mr Rice in the yard of his mill, *c*. 1910. The mills of William Rice stood on the Ham at the rear of the Borough Mills and were demolished in the 1950s.

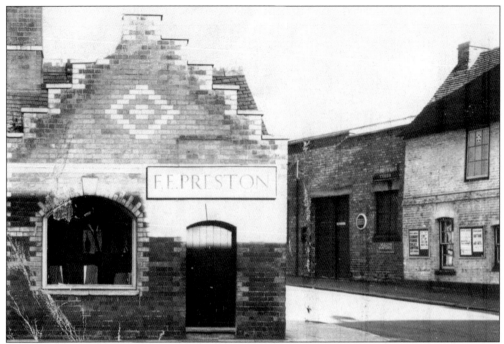

Mr Preston, a bespoke tailor, provided a service for the gentry and farming community in the area in 1959. His shop was situated at the corner of the High Street and Station Street before the redevelopment took place.

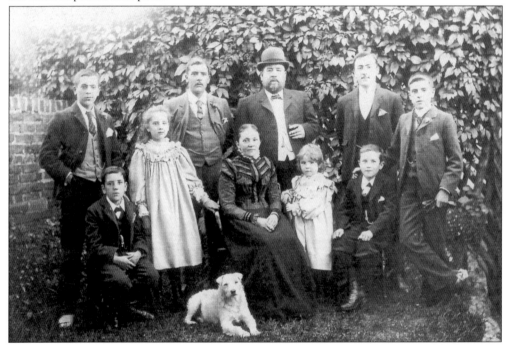

The Bloxhams were butchers in the town for many years, with a shop at No. 18 Church Street. This family group of 1900 includes, from left to right, back row: Heneage, Rowland, William (father) Herbert, Harry. Front row: Alan, Nellie, Elizabeth (mother), Daisy, Raymond.

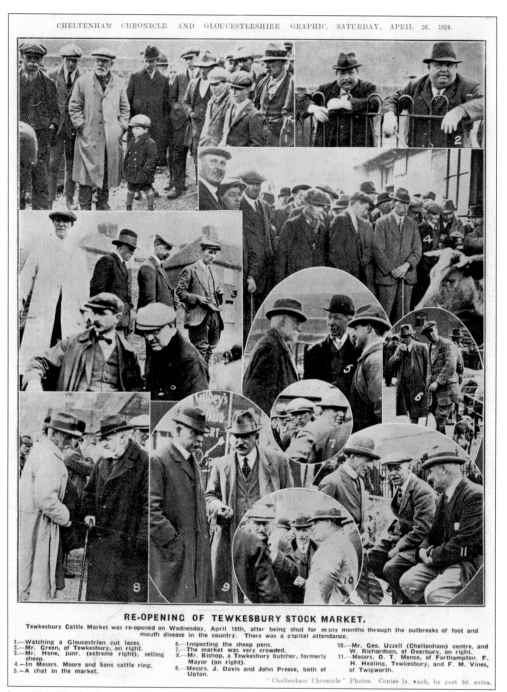

RE-OPENING OF TEWKESBURY STOCK MARKET.

Tewkesbury Cattle Market was re-opened on Wednesday, April 16th, after being shut for many months through the outbreaks of foot and mouth disease in the country. There was a capital attendance.

1.—Watching a Gloucestrian cut laces.
2.—Mr. Green, of Tewkesbury, on right.
3.—Mr. Hone, junr. (extreme right), selling sheep.
4.—In Messrs. Moore and Sons cattle ring.
5.—A chat in the market.
6.—Inspecting the sheep pens.
7.—The market was very crowded.
8.—Mr. Bishop, a Tewkesbury butcher, formerly Mayor (on right).
9.—Messrs. J. Davis and John Preece, both of Upton.
10.—Mr. Geo. Uzzell (Cheltenham) centre, and W. Richardson, of Overbury, on right.
11.—Messrs. O. T. Mence, of Forthampton. F. H. Healing, Tewkesbury, and F. M. Vines, of Twigworth.

"Cheltenham Chronicle" Photos. Copies 1s. each, by post 2d. extra.

In 1924, Tewkesbury cattle markets were closed due to foot and mouth disease in the area. These scenes at the re-opening on 16 April 1924.

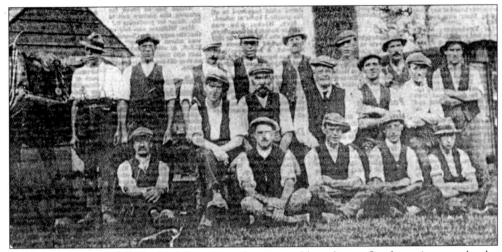

Land for building in Tewkesbury has always been a problem due to flooding. As a result, the land at Priors Park began to be developed by the local authority for council housing. This group of workmen seen here around 1929, are at the corner of Foresters Road and Abbots Road. In keeping with the tradition, the foreman is wearing a tie. Mr Parry is on the extreme left, while the other workmen include Mr Hyde, Mr Avery, Mr Pope, Mr Winters, Mr Jordan, Mr Drinkwater, Mr Goodwin, Mr Hopping, Mr Barrett and Mr Sallis.

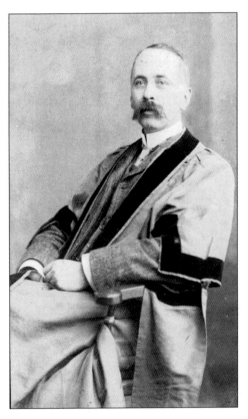

Mr W.H. Hayward wears the robes of a councillor of Tewkesbury Town Council, 1905. His family opened an ironmonger's business in the town in 1820; which is thriving today and still owned by the family and on the same site.

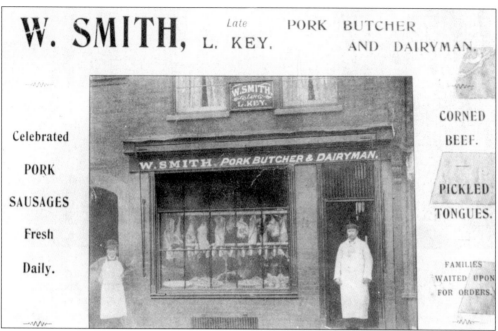

W. SMITH, *Late* **PORK BUTCHER**
L. KEY. **AND DAIRYMAN.**

Celebrated

PORK

SAUSAGES

Fresh

Daily.

W. SMITH. PORK BUTCHER & DAIRYMAN.

CORNED

BEEF.

PICKLED

TONGUES.

FAMILIES
WAITED UPON
FOR ORDERS.

Over the years the town has supported many butchers' shops. Mr Smith's shop in the High Street, seen here in 1904, carried on the tradition from his predecessor Mr L. Key. After this, Steve Healey also carried on the butchery business on this site.

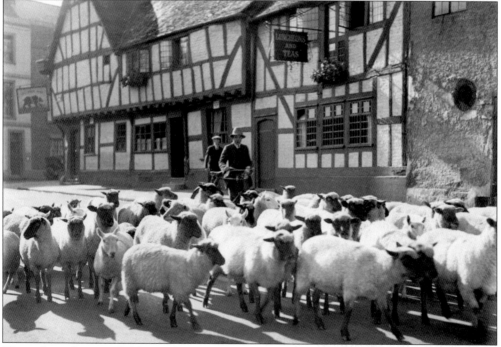

These sheep have probably just been bought at the weekly cattle market held by Moore and Son and George Hone the Auctioneers, 1920. These are being driven past the Black Bear pub and along the Mythe Road perhaps to Bushley or one of the other villages.

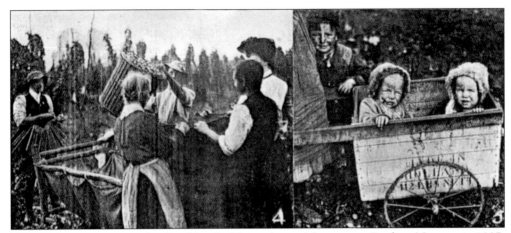

Hop growing was not confined to Herefordshire; these pickers are at Bredons Norton, in 1907. The farmer on the left is Mr Smith, and he has the tally sticks around his neck. He would cut a notch for every six baskets picked, for which the picker received one shilling.

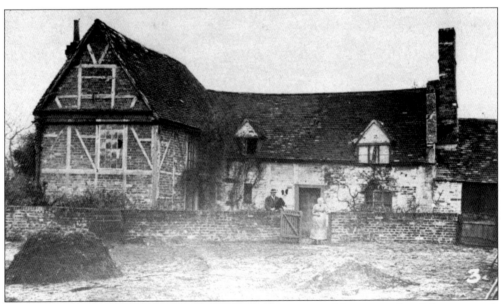

These farm buildings, near Ashchurch, are an amalgamation of the spiritual and the temporal. The half-timbered structure on the left was an early Baptist chapel, built by the ancestors of Mrs Purser, seen here with her husband in 1928. A later window has been added to the chapel building.

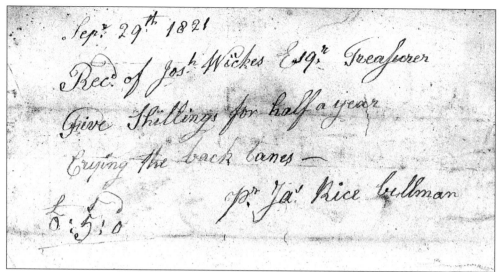

The Town Crier was used by most organizations in the town at some time but was still an officer of the Town Council and was used to 'shout' any notices issued by them. This receipt dated 29 September 1821, is for the sum of five shillings, for 'crying the back lanes', signed Jas. Rice, Callman.

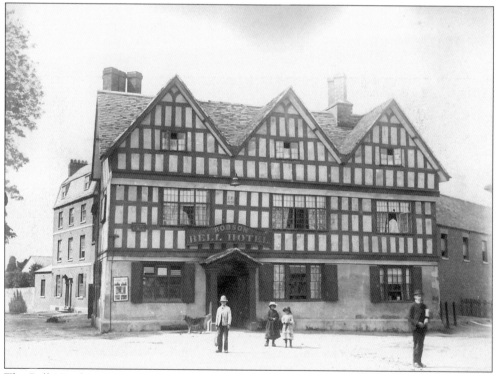

The Bell Hotel in 1889. The building was also known as the Bell and Bowling Green, and at an earlier date, the Angel. Above the front entrance is the date 1697, which probably refers to an earlier reconstruction or some other major change. Inside the building are the remains of early wall paintings.

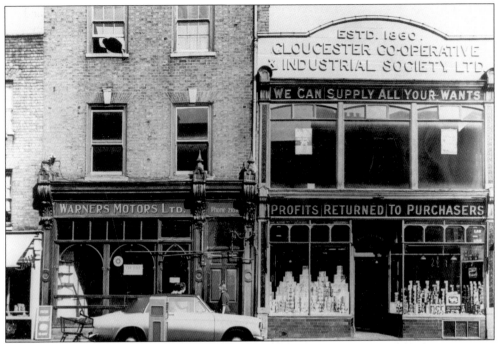

The first branch of the co-op to be opened in Tewkesbury was at No. 114 High Street and had its own bakery and stables. This is the newer shop front built around 1930. The shop closed in 1965 when rebuilding took place.

Spa House on the Ashchurch Road, 1928. In an attempt to compete with Cheltenham as a spa, this building was raised to accommodate customers wishing to take the waters at Tewkesbury. The spring water was analysed and found to be of a similar composition to that of Cheltenham. Alas the project, like that of Swindon and many others, did not take off. The building remained standing and was used to store farm machinery until the late 1950s, when the site was cleared for development.

At the junction of the High Street and Smiths Lane we can se the old Abbey Brewery building on the left. This is around 1960, just before the brewery was removed to make way for a supermarket. The hoist was the highest in the town.

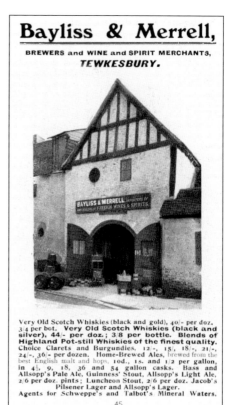

Bayliss & Merrell,

BREWERS and WINE and SPIRIT MERCHANTS,
TEWKESBURY.

Very Old Scotch Whiskies (black and gold), 40/- per doz. 3/4 per bot. **Very Old Scotch Whiskies (black and silver), 44/- per doz.; 3/8 per bottle. Blends of Highland Pot-still Whiskies of the finest quality.** Choice Clarets and Burgundies, 12/-, 15/, 18/-, 21/-, 24/-, 36/- per dozen. Home-Brewed Ales, brewed from the best English malt and hops, 10d., 1s. and 1/2 per gallon, in 4½, 9, 18, 36 and 54 gallon casks. Bass and Allsopp's Pale Ale, Guinness' Stout, Allsopp's Light Ale, 2/6 per doz. pints; Luncheon Stout, 2/6 per doz. Jacob's Pilsener Lager and Allsopp's Lager.
Agents for Schweppe's and Talbot's Mineral Waters.

45

Bayliss and Merrell, one of several breweries in Tewkesbury in 1908. Originally situated next to the Black Bear Inn, these buildings next to the river are now the garden for the pub.

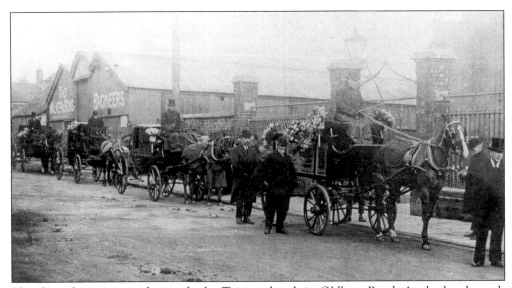

This funeral cortége stands outside the Trinity church in Oldbury Road. At the head stands Bartholomew Sweet, head of the old established firm which still flourishes. The driver of the third coach from the front is Fred Proctor, a 'conscientious objector', in the First World War, who was placed in Dartmoor Prison for his beliefs. The driver of the front coach is the landlord of the Kings Head in Barton Street, Henry Davies. In the background can be seen Walkers Engineering factory, the company which made fairground machines.

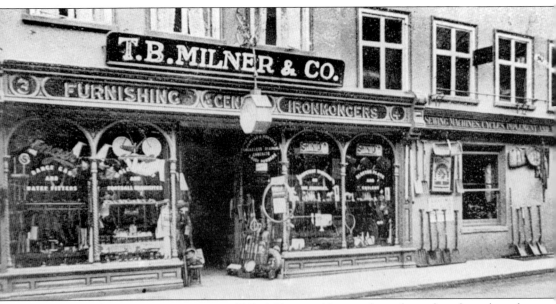

A typical Victorian ironmongers, T.B. Milners sold everything from shovels and spades to sewing machines and sports equipment. The shop, seen here in 1904, occupied Nos 3-4 High Street, a site later occupied by Woolworth's. Milners also owned the Halifax factory in St Mary's Lane.

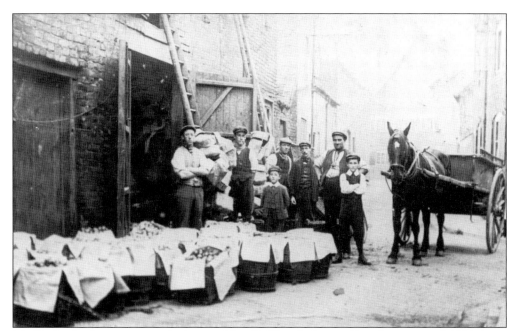

Mr Healey had a greengrocer's shop at No. 63 Church Street. Seen here around 1920, he is collecting barrels of apples as well as other goods for the shop, from an Evesham supplier.

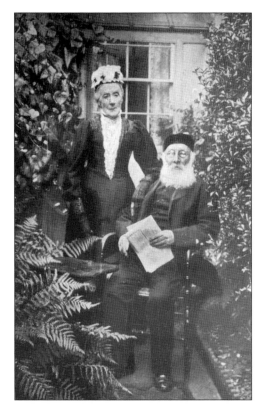

In 1908 Mr and Mrs Papps celebrated their Diamond wedding anniversary. Mr Papps was a prosperous businessman in the town, owning two establishments in prime sites in the High Street. He sold bed linen and other cotton goods.

B. COOK & SON,

NURSERYMEN & AVONBROOK
FLORISTS. NURSERIES,

Church Street, Tewkesbury.

Presentation and Bridal Bouquets, Memorial Wreaths, Crosses,
Anchors, and other Floral Designs to order.

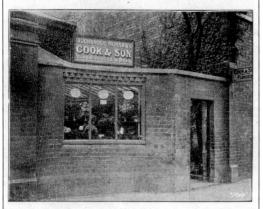

Rose Trees, Fruit Trees, Shrubs and Herbaceous Plants.

**PEAT, SILVER SAND, FLOWER POTS AND OTHER
—— HORTICULTURAL SUNDRIES SUPPLIED. ——**

Nurseryman Ben Cook had his shop on the right hand side of the main entrance to the High School in Church Street, in 1900. He later he moved to a shop at No. 21 High Street.

J. W. TYSOE,

Established more
than half a
century.

5, Barton Street, Tewkesbury.

General Grocery and Provision Stores.

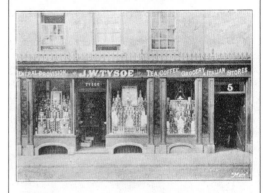

ACCOUNTS RENDERED QUARTERLY.

ORDERS from the Country, either by Post or by Carrier,
have best attentton, are carefully packed and delivered
carriage paid.

Tysoe's shop was situated at Nos 4-5 Barton Street and, seen here in 1925, it was almost an institution in the town. There was a large storeroom especially for cheese, which he advertised regularly, and like most shops, he delivered to the surrounding area, carriage paid.

Mr Dodson was a 'high class fruiterer', according to the 1904 advertisements in the Town Guide. His shop in the High Street also boasted an excellent display of hanging and potted plants.

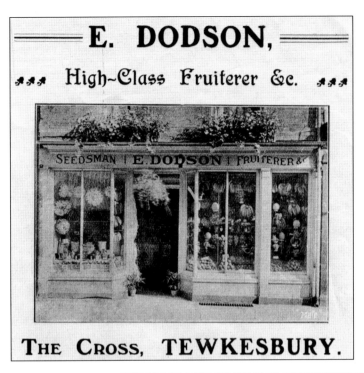

E. DODSON,

High-Class Fruiterer &c.

THE CROSS, TEWKESBURY.

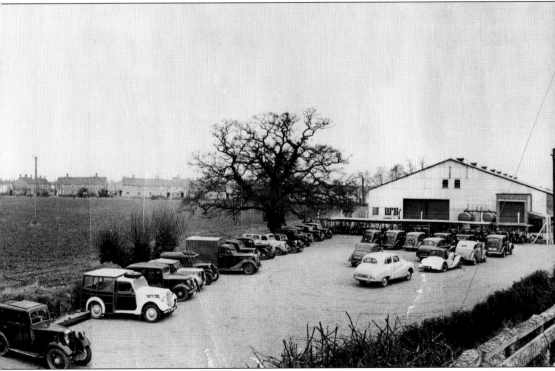

The Dowty factory at Northway with the housing estate in the background. This was taken around 1956 from the old railway bridge and shows the car park which was later to be the site of the Dowty Mining factory.

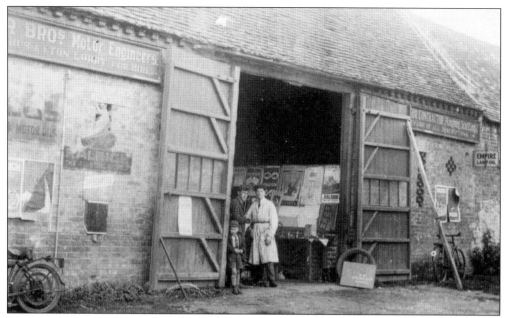

Warners, the coach company and car sales organization, are well known in the county. Here, around 1935, they operated from a workshop in Twyning. Later they had a large garage in the Oldbury, opposite the old cattle market. They provided transport for all the major firms in the area, taking employees to and from work. At this time, however, they offered a one-ton lorry for hire and repaired agricultural implements.

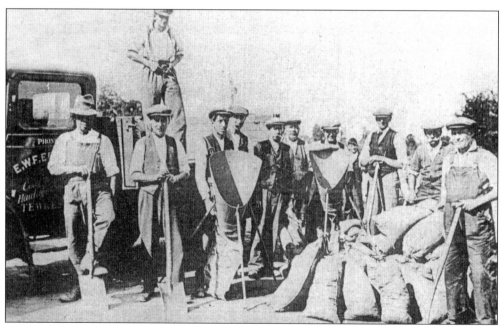

'Sand Brigade' in 1940. As part of the civil defence of Tewkesbury, these workmen were employed by the borough council to fill the sandbags at the beginning of the war. Sixth from the left is Mr George Carter and the others include Mr Green, Mr Collins, Mr Evans, Mr Abbott, Mr Parker, Mr Scrivens and Mr Barnes.

Six
People and Events

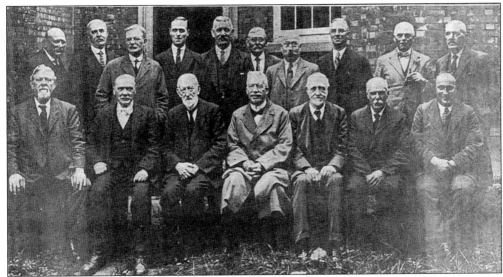

Tewkesbury Town Council in 1931. This picture was taken in the garden at the rear of the Town Hall, and at this time almost all of the council were local businessmen. From left to right, back row: W. Walkley, C. Matthews, Revd H.G. Brown, S.C. Moulder, C. Mellor, A. MacDonald, C.E. Hopkins, R.A. Gaze, C.A. Roberts, W. Ridler (surveyor). Seated: J. Walker, G.P. Howell, Alderman A. Baker, Mayor L.L. Stroud, Alderman W.T. Boughton, Alderman J.W. Howell, A. Jordan.

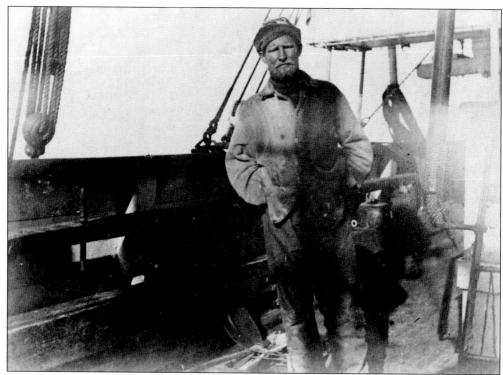

Scott's Polar Expedition of 1907-1909 has strong local connections. Raymond Priestley was the son of the headmaster of the Grammar School and as a geologist was engaged by Shackleton to join the party going to the South Pole. He became Vice Chancellor of Birmingham University and was a close friend of the Duke of Edinburgh. He stands on the deck of the ship here, heading south. He later became Sir Raymond Priestley.

John Rogers, a Tewkesbury centenarian, on his one hundredth birthday, in November 1908. He was a well-respected businessman, and in a diary that he wrote around 1900, he left behind a valuable record of the town and some of its inhabitants. He recorded details of the alleys and courts and the people living in them, which has proved invaluable for local historians.

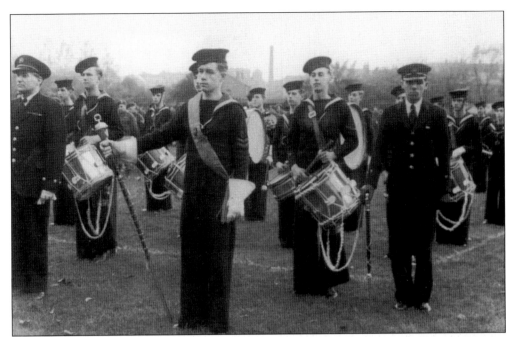

The drummers of the Tewkesbury Sea Cadets were seconded to the Cheltenham parade for the VJ march in September 1945. From left to right: drummer Derek Graham, -?- (parade leader), Bob Robertson, Barry Sweet.

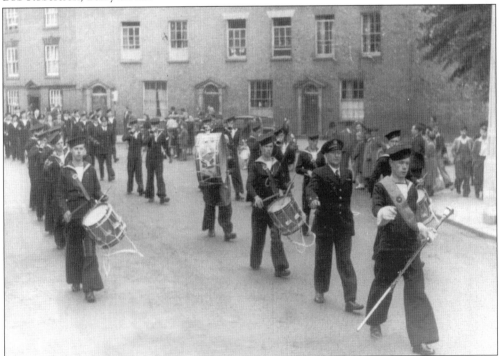

Victory at last and the Sea Cadets Parade are passing the Crescent on its way to the Abbey in 1945. From left to right, front row: Barry Sweet and Ivor Davis are on the drums with Bob Robertson leading the parade.

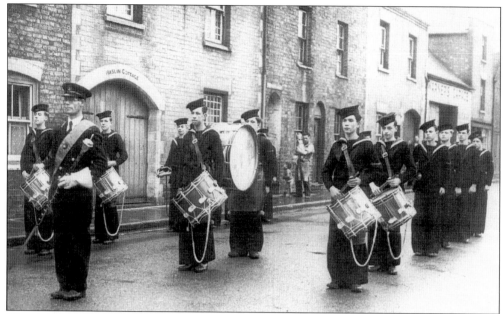

Church Parade for the Tewkesbury Sea Cadets in 1944, who are waiting for the order to march off. From left to right: Barry Sweet, -?- (bandmaster), Derek Graham, 'Slim' Hobbs, D. Cash, -?-, Ivor Davis, G. Willis, Albert Percival, Ken Parsons, ? Rudd. In the background is Mr Booth with his two children.

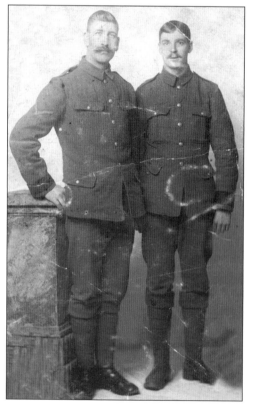

Joseph Walker (left) with one of his comrades shortly after volunteering for service with the Glosters in 1914. Joseph had been a bargehand, working on the River Severn, mainly between Tewkesbury and Bristol. He lived in Bank Alley before enlisting and was killed in action in 1916.

Ray Bloxham was one of two Tewkesbury lads who emigrated to Australia in 1912. He joined the Queensland Light Horse and is seen here in 1915 in Egypt. Later in the campaign, he met up with Lawrence of Arabia, and went on to win the Military Medal.

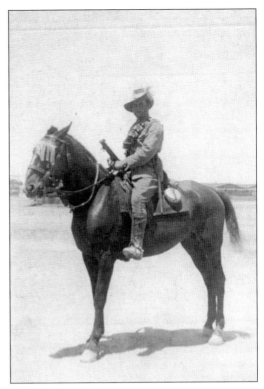

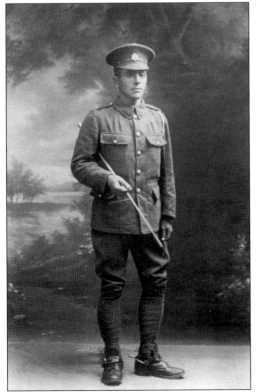

Obviously an influence on his brother, Harry Bloxham went to Australia in 1910, together with Jack Shill and Allan Tysoe. He returned in 1915 and enlisted in the 13th Hussars. After the war he went back to Australia where he worked as a sheep farmer.

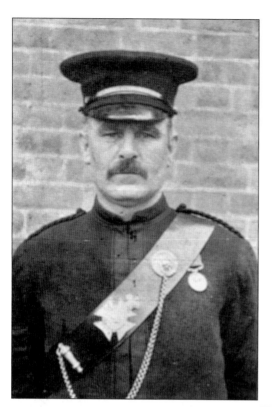

Col.-Sgt Ireland, the military instructor for the Tewkesbury Territorials, 1908. He had been a regular soldier for twenty-four years and held the post of instructor for four years. The Territorials were some of the first to volunteer for service in the First World War. As trained soldiers some of them would have become NCOs, training new recruits.

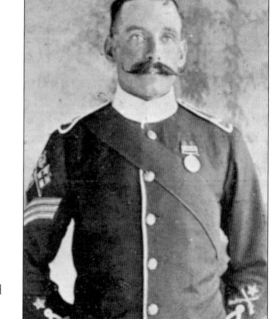

The successor to Sgt Ireland in 1908 was Col.-Sgt Chapman, another professional soldier who had fought in South Africa and had seen service in India. He carries a Marksman's Badge on his left sleeve.

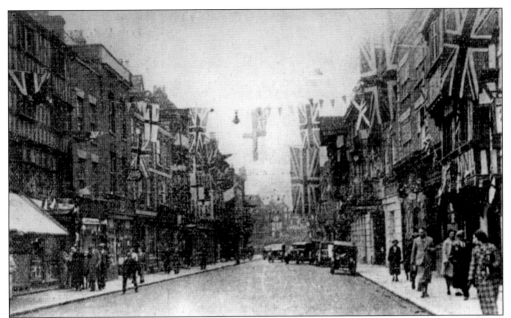

The High Street is decked out with flags and bunting, probably for the Coronation of George VI in 1937, as was the usual tradition. Note the Austin Seven parked on the right and the natty style of the 'plus foured' gent.

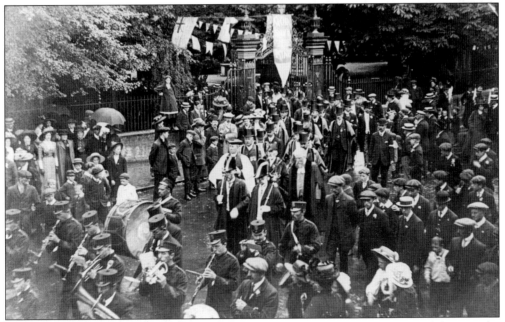

The Tewkesbury Town Council has just attended a service at the Abbey, celebrating the coronation of King George V in June 1911. The town band, (with bandmaster Styles), precedes the Mayor Alderman A. Baker, Chaplain Canon Yerburgh and the town clerk, H.A. Badham. The councillors are all wearing top hats, while straw boaters seem to be the accepted headgear for most others.

BOROUGH OF TEWKESBURY.

A
PUBLIC MEETING

Of the Inhabitants, will be held at the

TOWN HALL,

ON

Tuesday, December 19, 1899

FOR

THE PURPOSE OF FURTHERING THE OBJECTS OF THE

SOLDIERS AND SAILORS'

FAMILIES' ASSOCIATION,

AND TO

FORM A COMMITTEE FOR COLLECTING FUNDS.

The Chair will be taken at 8 p.m., by

HIS WORSHIP, THE MAYOR.

LAWLER, PRINTER, TEWKESBURY—5071.

It seems rather surprising that there should be such a meeting in the town in December 1899, as we associate this organization with today's society. However, Tewkesbury has always looked after its needy. This organization, now known as SSAFA, is still very active nationally.

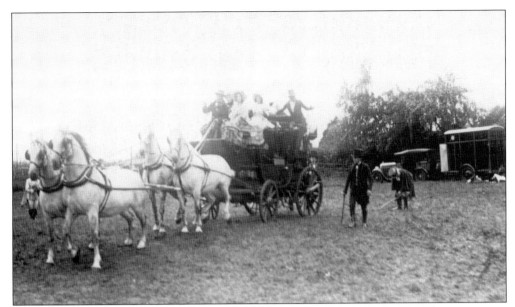

Members of the Dickens Fellowship in 1928, a popular organization in the town for many years, are boarding their coach for a tour of the pubs of the town. They stopped at each of the hostelries and partook of liquid refreshment!

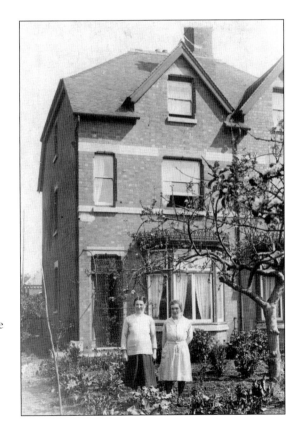

Sunny View House, Rope Walk, c. 1936. Mrs Rees and her daughter pose in the front garden. This is one of the fine villas in an area which was developed after the Enclosure Act of 1808, and was the site where the ropemakers would have had their wheels and laid out their ropes.

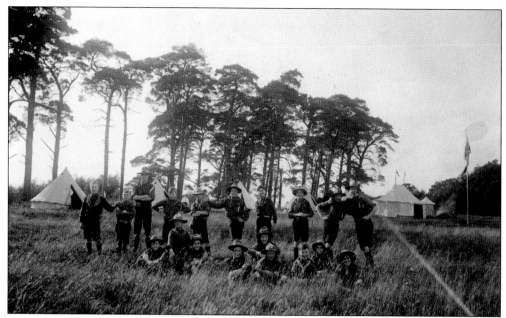

The Gloucester Scout Group is enjoying its annual camp at Tewkesbury, c. 1930. The site is Queen Margaret's Camp, an ancient site opposite the Gupshill Manor, a regular venue for Scouts and other groups between the wars.

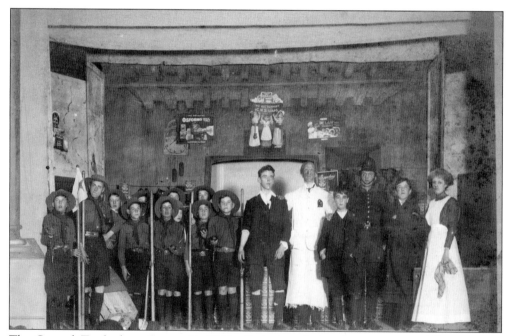

The Second Tewkesbury Scouts in 1930, displaying their talents on stage. The venue is probably the Methodist or the Abbey Hall. Local youth groups regularly put on this kind of concert, providing entertainment locally before television came on the scene.

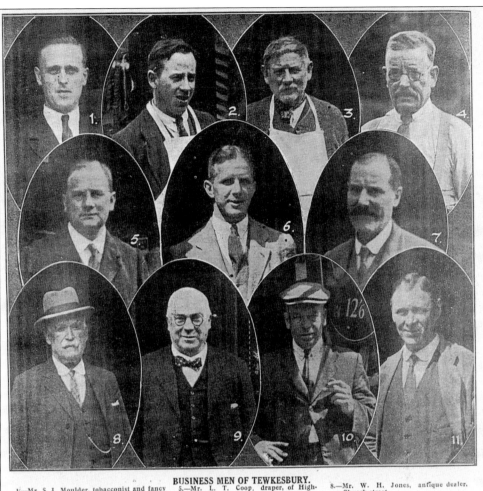

BUSINESS MEN OF TEWKESBURY.

1.—Mr. S. J. Moulder, tobacconist and fancy goods dealer, High-street.
2.—Mr. T. A. Reynolds (son), and
3.—Mr. S. J. Reynolds (father), of Reynolds and Son, harness makers, for over 40 years in business in High-street.
4.—Mr. A. C. Bathurst, boat builder and engineer, of The Avon Boating Establishment.
5.—Mr. L. T. Coop, draper, of High-street.
6.—Mr. W. Fisher, of The S.W.S. Electric Power Company, High-street.
7.—Mr. J. Maynard, manager of Gloucester Co-operative Society business in Tewkesbury.
8.—Mr. W. H. Jones, antique dealer, Church-street.
9.—Mr. W. R. Hopkins, tobacconist, High-street.
10.—Mr. J. Payton, cycle engineer, High-street.
11.—Mr. Ben Burford, landlord of the Coach and Horses, Tewkesbury.

"Cheltenham Chronicle" Photos. Copies 1s. each.

A series of photographs taken in 1930 of the businessmen who traded in the town. Many of these were old-established businesses, which continued throughout the war and after. Mr Moulder, top left, can also be seen in the council picture on p. 69. From left to right, top: S.J. Moulder, T.A. Reynolds (son), S.J. Reynolds (father), A.C. Bathurst. Second row: L.T. Coop, W. Fisher, J. Maynard. Bottom row: W.H. Jones, W.R. Hopkins, J. Payton, B. Burford.

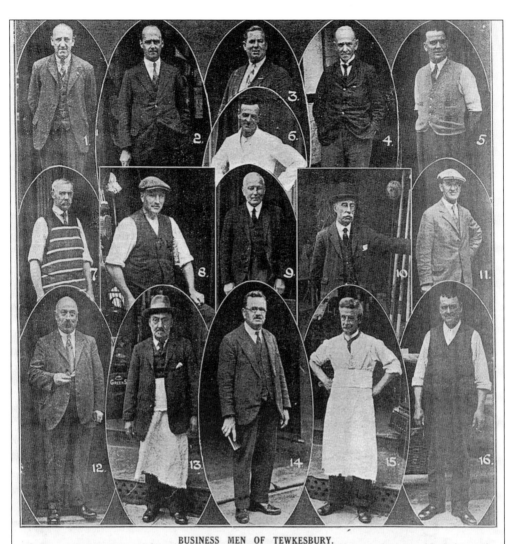

BUSINESS MEN OF TEWKESBURY.

We have much pleasure in publishing above a series of portraits of many of the well-known business men of Tewkesbury, and hope to continue the series in the near future.

1.—Mr. F. J. Simcox, jeweller, High-street.
2.—Mr. R. A. Newman, bookseller and stationer, High-street.
3.—Mr. M. L. Willis, hairdresser, High-street.
4.—Mr. H. Hewett, the art shop (Sally Watkin's Cottage).
5.—Mr. F. Dee, of Berkeley Arms, an old-fashioned licensed restaurant.
6.—Mr. Bassett, provision dealer and tea rooms.
7.—Mr. C. Matthews, butcher, The Cross.
8.—Mr. J. Wilkins, toys and fancy goods, Barton-street.
9.—Mr. A. Williams, draper and tailor. The Cross.
10.—Mr. H. King, ironmonger, High-street (55 years in business).
11.—Mr. J. Willis, jnr., confectioner, The Cross.
12.—Councillor C. E. Hopkins, draper, High-street.
13.—Mr. J. J. Price, grocer's manager of Messrs. Allen Bros.
14.—Mr. H. Dyer, manager of Messrs. John Dobell and Co., with nearly 40 years' service.
15.—Mr. J. Allen, grocer, High-street.
16.—Mr. Arthur Cleal, fruiterer, Barton-street.

In this gallery of local businessmen in 1930, there is another councillor seen at the bottom left, Mr C.E. Hopkins. Photograph No. 3 shows Monty Willis who was a hairdresser with a shop in the rear of a tobacconists in the High Street, and is remembered by many for having a wooden leg. Harry Hewett (photograph No. 4) was also a local entertainer and an artist. From left to right, front row: F.J. Simcox, R.A. Newman, M.L. Willis, H. Hewett, F. Dee. Second row: C. Matthews, J. Wilkins, H. King, J. Willis. Bottom row: C.E. Hopkins, J.J. Price, H. Dyer, J. Allen, A. Cleal.

80

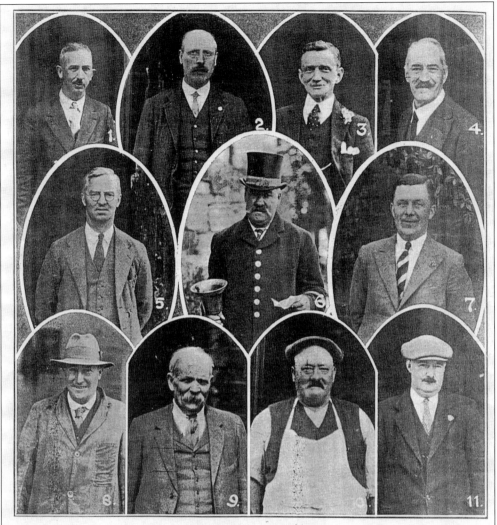

BUSINESS MEN OF TEWKESBURY.

Well-known men in the business life of Tewkesbury, snapped by our photographer this week. This is the third set published.

1.—Mr. G. T. Troughton, fruiterer and florist,
2.—Mr. Wm. Evans, boot and shoe factor.
3.—Mr. Tom Gannaway, tailor and hosier.
4.—Mr. G. E. Hayward, ironmonger.
5.—Coun. R. A. Gaze, milk contractor.
6.—Mr. Tom Green, town crier.

7.—Mr. S. T. Freeman, landlord of The Bell Hotel. He has played for Gloucestershire at cricket and for the past three years has been captain of Gloucestershire Club and ground.
8.—Mr. Tom Jordan, of Gloucester-road Garage.

9.—Councillor C. Crouch, baker.
10.—Mr. Steve Healey, butcher, High-street. He has been a butcher in Tewkesbury for 48 years, 25 at his present shop.
11.—Mr. G. T. Clapham, secretary of Tewkesbury and Bredon Show, and Collector of Taxes.

"Cheltenham Chronicle" Photos. Copies 1s. and 1s. 9d. each.

There are three more councillors in this group, together with Mr Tom Green, the town crier. Mr Freeman (No. 7) was landlord of the Bell Hotel, and also played cricket for Gloucestershire. Mr Steve Healey was a butcher in the town for forty-eight years. From left to right, top row: G.T. Troughton, W. Evans, T. Gannaway, G.E. Hayward. Second row: R.A. Gaze, T. Green, S.T. Freeman. Bottom row: T. Jordan, C. Crouch, S. Healey, G.T. Clapham.

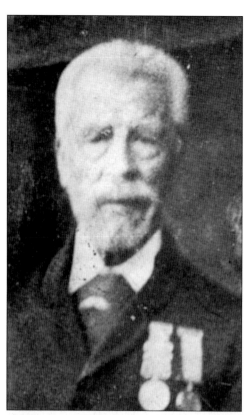

This is William Hawkes in 1908. He was a native of the town and an old soldier who had fought at the battle of Inkerman during the Crimean War, with the Fifth Dragoon Guards. He was for many years an instructor for the Territorials.

These are long-serving employees who worked at Healings Mill, 1945. Between them they had clocked up 337 years of service and were all in their seventies when the picture was taken. From left to right: William Dean, William Coombes, Christopher Dean, Walter Hotchkins, -?-, Charles Halling, William Simons.

An advertisement for Hewetts Punch and Judy show, 'available for fêtes and bazaars', *c.* 1910. Hewetts had a shop in Barton Street which sold art supplies, hired out fancy dress costumes, etc. Harry Hewett was also an accomplished watercolourist, and his work can still be seen in the town.

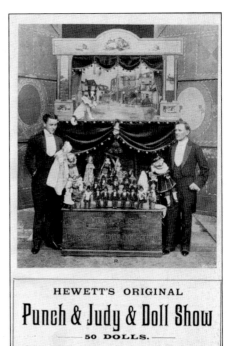

HEWETT'S ORIGINAL

Punch & Judy & Doll Show
—— 50 DOLLS. ——

Children's Parties, Fetes and Bazaars attended. Fancy Costumes on hire, also all kinds of Scenery for sale or hire. Bazaars fitted at moderate charges. *For Terms apply to*—

H. HEWETT, 5, High Street, Tewkesbury,
THE HOUSE FOR GUIDE BOOKS.

The crowning of the Carnival Queen for Tewkesbury, *c.* 1950. The queen, Miss Pat Gallon, is standing with her two Maids of Honour on the left, Miss Edith Smith and Miss Joan Morgan. On the right is the outgoing queen, Miss Daphne Salisbury, with the Mayor Alderman Frank Knight looking on.

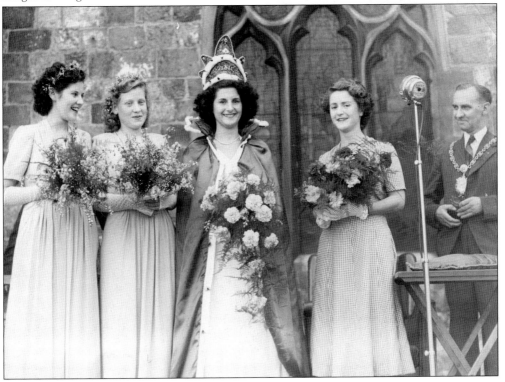

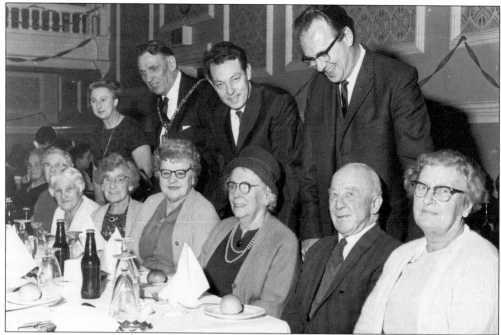

In 1970 a Christmas Dinner for the Golden Hour Club was provided by the Tenants Association and held at the Watson Hall. From left to right, at the rear: Mrs Griffiths, the Mayoress, Mayor John Griffiths, Cliff Burd and Derek of the Tenants' Association. Seated at the extreme right: Mrs Florence Hodges and Mr Jack Lewis.

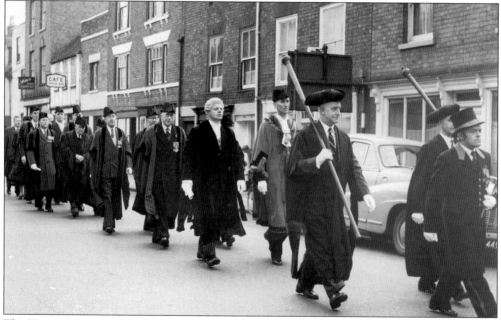

The Town Crier, Mr Ted Preston, leads the mayor's parade through Barton Street to the Abbey for the Civic Service, in 1960. The town clerk with Mayor Harry Workman, walking behind the Mace Bearers, is followed by Aldermen Troughton, Lane and Sweet, with other councillors, including, John Griffiths and Leslie Webber, and council officers bringing up the rear.

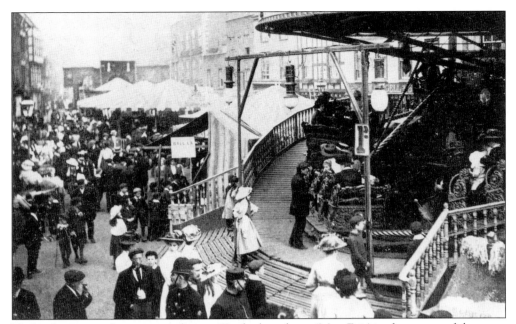

Under the terms of an ancient charter, Tewkesbury has a 'Mop Fair' in the streets of the town every October. This used to be a hiring fair, where farmers would hire labour for the next year's work. This is a view of Barton Street in 1910, and the cost of a ride then was only one penny! The police are out in force with both Constable and Superintendent in the foreground.

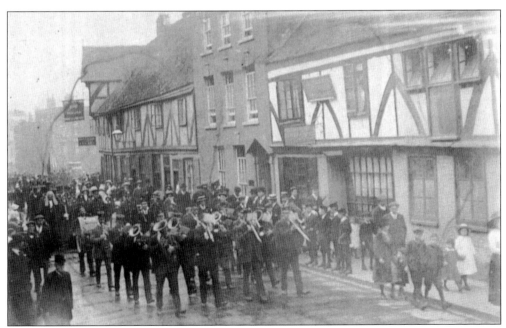

The Town Band leads the Corporation along Church Street to the Abbey, for a service celebrating the coronation of King George V, in June 1911. The day has obviously been wet, but a large crowd has turned out.

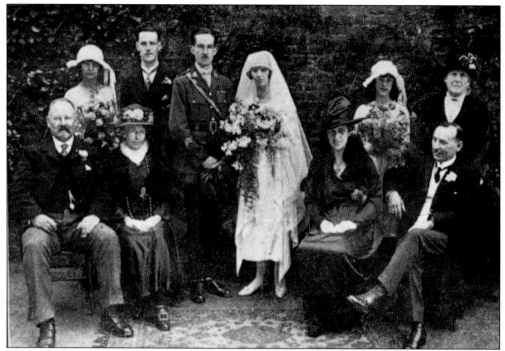

The wedding of Bill Lane, an ex-army officer, to Queenie Williams in 1921. She was a local girl whose parents were in business at the Cross. Bill Lane later entered local politics and became mayor of Tewkesbury.

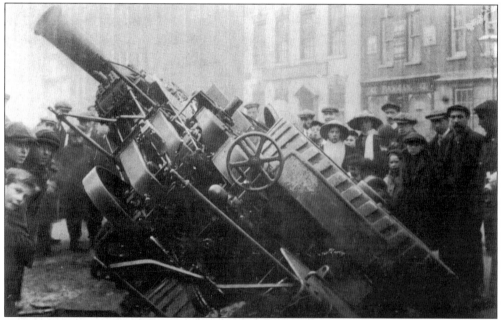

A major accident in the High Street, c. 1900. A steamroller went through the plate of the weighbridge, outside the Happy Returns pub, which had to close in 1916 due to the fall-off in business caused by the war. The event has attracted a crowd of onlookers, always eager to see something unusual!

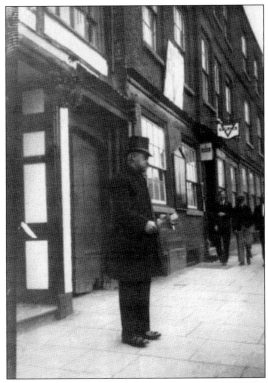

Mr Green was the Town Crier – one of a long line of officers of the council who have 'shouted' around the town. He is seen here around 1930 outside the YMCA building in Church Street preparing to shout. His hat and bell are still preserved in the town Museum.

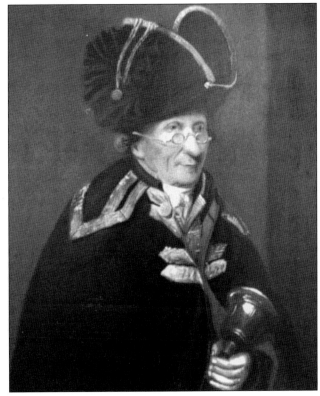

William Rice was the 'Common Crier' for Tewkesbury. When this portrait was taken in 1820, he was seventy-seven years old. The portrait hangs in the Council Chamber at the Town Hall and was given to the town by two councillors of the time.

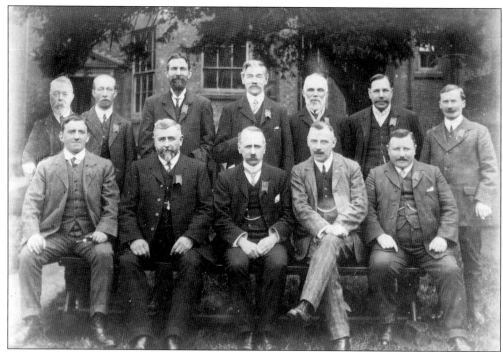

The committee of the Daffodil Society in 1928, at the rear of the Town Hall. All the local shows traditionally took place in the Corn Exchange of the Town Hall.

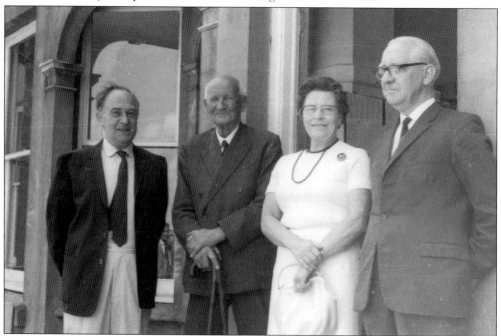

The platform party for Speech Day at the Grammar School, 1970. From left to right: George Brown (the headmaster), Sir Raymond Priestley (the explorer), Mrs Brown, Alderman Frank Knight (the chairman of the governors). Sir Raymond Priestley's father founded the original Tewkesbury Grammar school, when the old Abbey school was amalgamated in the late 1800s.

A LIST OF Paupers Receiving Parochial Relief, IN THE PARISH OF TEWKESBURY.

In June, 1832.

PAUPERS ON THE REGULAR PAY BOOK:

Names	Age	Residence	Weekly Pay
Allen, Widow	68	Alms Houses	1 6
Attwood, Jane	86	Ditto	2 0
Buckle, Eliz.	79	Ditto	2 0
Buckle, Ann	70	Old Workhouse Alley	1 6
Bullock, Widow	86	Alms Houses	2 0
Collett, John (blind)	68	Davis's Alley	2 6
Coulston, Sarah		Castle Morton	2 6
Davis, Wm.	71	Oldbury	3 0
Evans, Eliz.	82	Millbank	2 0
Evans, John	91	Back of Swilgate	2 6
Eveness, Elias	58	Orchard Court	2 0
Finch, Wm. (blind)	74	Mr. Barnes' Houses	3 0
Goteman, Widow	77	Millbank	2 0
Hall, Charles	86	St. Mary's Lane	2 0
Hardman, Charlotte	66	Double Alley	2 0
Hawkins, Eliz.	66	Alms Houses	2 0
Jones, Widow	80	Mr. Barnes' Houses	2 6
Jones, Widow	68	Tolsey Lane	1 6
Kinson, Jane	86	Alms Houses	2 6
Macpherson, Widow	75	Hays' Alley	1 6
Owen, John	86		2 6
Pittway, Widow	80	Mr. Barnes' Houses	2 0
Pumphrey, Eliz.	85	Alms Houses	2 0
Pumphrey, Widow	73	Gander Lane	2 0
Randle, Eliz.		Mr. Barnes' Houses	2 0
Rean, Wm.	78	Oldbury	2 6
Reynolds, Ann	80	Gander Lane	2 0
Ricketts, Wm. (blind)	68	Scott's Alley	3 6
Sharp, Honor	56	Tolsey Lane	1 6
Parker, Joseph	54	At Mr. Lilley's	1 0
Southall, Mary (1 arm)	79	Oldbury	3 0
Trueman, Ann	92	Ditto	3 0
Vevers, Wm.	77	Mr. Barnes' Houses	2 0
Walker, Sarah	41	Ditto	2 0
Waring, Mary	74	Alms Houses	2 0
Whittle, John	82	High Street	2 0
Williams, Roderic	71	Mr. Barnes' Houses	2 0
Wilkins Sam, and wife	73	High Street	4 6
Woodward, Marg.	81	Alms Houses	1 6

OCCASIONAL RELIEF.

Name	Age	Residence	No. of Children	Weekly Pay
Allen, Marshal	33	...	4	1 6
Ammott, Tho. & Wife		Orchard Court		2 0
Anderson, Widow	66	Double Alley		1 0
Anderson, Ed.	27	Ditto	2	1 0
Ashwin, John (wife ill)	50	Merrett's Alley	2	2 0
Baker, John (ill)	35	Crooked Alley	5	5 0
Barnes, Samuel	59	Smith's Lane	1	1 6
Bell, Widow	49	Barton Street	6	6 0
Bishop, Edw.	22	St. Mary's Lane		2 6
Bishop, John		Oldbury	5	2 0
Blizard, Eliz.	71	Merrett's Yard	1	0
Bowers, Widow	62	St. Mary's Lane	1	0
Brookes, John		Oldbury	4	4 0
Buckle, Widow	45	Mill Bank	5	6 0
Bull, James	37	...	4	3 0
Carloss, Sarah	50	Bishop's Alley	1	1 0
Care, Thos.		Mr. Barnes' Houses	2	1 0
Chapman, Geo.		Double Alley	3	1 0
Clay, Eliz.	54	Back of Swilgate	1	1 6
Cooper, Charles (ill)	27	Cull's Alley	1	1 6
Cooper, Thomas	70	Church Street	1	0
Collins, Susan	54	St. Mary's Lane	2	0
Cull, Widow	60	Hughes' Alley	1	0
Collins, Mary		Back of Swilgate	1	1 0
Cotnett, Widow		Mr. Barnes' Houses	1	2 0
Coldrick, Sam.	71	Charlwood's Alley	1	6
Crump, Wm.	83	Sun Alley	3	4 0
Crump, Ann (ill)	77	Scott's Alley	1	6
Cullis, Widow	44	Dobbins' Alley	3	3 0
Dale, Patience (very ill)	30	Warder's Alley	1	4 0
Davis Wm. Jun.	40	Oldbury	3	2 0
Davis, Mary	2	Back of Mr Packer's	1	0
Davis, Sam.	75	Bank Alley	2	0
Dean, Wm.	66	Oldbury	5	4 0
Douglas, Mary	53	Church Street	1	6
Dowling, Eliz.		...	1	0
Dowding, Jane	57	Eagle's Alley	1	0
Drinkwater, Jane	76	Finch's Alley	1	6
Drinkwater, B. (ill)	21	Ditto	1	6
Drinkwater, Jno. & wife	71	Oldbury	3	0
Dyer, John		Ashton-under-hill	5	2 0
Elton, Thomas	77	Joynes' Alley	1	6
Elton, Mary	77	Oldbury		1 0
Evans, Widow (ill)		Thomas's Alley	2	4 0
Fletcher, William	30	Joyce's Alley	5	4 6
Gainer, Lewena	46	Long's Alley	1	1 0
Gannaway, Josiah	44	St. Mary's Lane	4	1 0
Godsall, Elisha	48	Mill Bank	2	1 3
Granger, Widow	43	Mill Bank	3	5 0
Hampton, Eliz.		Barton Street	1	1 0
Harvey, Ann	22	St. Mary's Lane		1 0
Harris, Eliz.	49	Mr. Barnes' Houses	1	6
Harris, John	21	Overbury	3	0
Harris, Cath.	20	Workhouse Alley	1	6
Hayward, Mary	75	Crooked Alley	2	6
Hemming, Widow	53	Church Street	1	2 0
Hendry, Joseph		Oldbury	3	1 0
Hodges, Ann	38	Gander lane	1	1 0
Holbrook, John		Merrett's Yard	1	0
Hyatt, Widow	69	Smith's Lane	1	0
Late E James' child		At William Steel's	1	6
Jones, Harriet		Oldbury	1	0
James, William	61	St. Mary's Lane	1	6
Key, Enoch	32	Hughes' Alley	4	2 0
King, John	72	Crooked Alley	1	2 6
Kinson, John	82	Fletcher's Alley	1	2 0
Lane, Widow	46	Compton's Alley	6	6 0
Lawrence, Ann	47	Gander Lane	3	4 0
Lawrence, Widow's child	7	Barton Street	1	6
Leonard, John	76	St. Mary's Lane	1	0
Long, James (wife ill)	52	Davis's Alley	3	0
Lucey, William	58	O. Meat House Alley	1	6
Lyes, Harriet	13	Barton Street	1	6
Mann, Widow	40	High Street	3	0
Mann, William	41	Oldbury	4	3 0
Matthews' children		Eagle's Alley	2	6
Merrick, Edwin	27	Scott's Alley	4	1 6
Mills, Widow	29	St. Mary's Lane	2	2 6
Moore, Hannah	73	Merrett's Yard	1	0
Morris, William	60	Oldbury	3	0
Nicholls, Thomas	46	Eagle's Alley	3	1 6
Nicholls William	73	Sun Alley	1	6
Nind, Widow	63	Joynes's Alley	1	0
Owen, Anthony	78	Red Lion Alley	1	6
Owen Philip	37	Stephen's Alley	5	1 6
Painter Widow	68	St. Mary's Lane		1 6
Parsons Widow	74	Wall's Alley		1 6
Parker, Joseph	55	Oldbury	2	4 2
Pittman, Joseph's Wife	36	Ditto	5	6 0
Patterson, Hannah	39	St. Mary's Lane		1 0
Parsons, M. A. (ill)	28	Grafton		2 0
Preece, Joseph	25	Bishop's Alley	3	2 0
Pugh, Thomas (ill)	65	Snelus's Alley	2	2 0
Pumphrey, Maria	19	St. Mary's Lane		2 9
Rice, Thomas	36	Glover's Alley	5	6 0
Rice, Widow	44	Eagle's Alley	4	5 0
Rice, James	69	Gander Lane		1 0
Roberts, Widow		Oldbury		1 6
Smart, Eleanor	46	Barton Street		1 6
Staite, Ann (lame)	34	Eagles's Alley		2 0
Staite, Lydia	57	Ditto		2 0
Staite, Widow	50	Oldbury		1 0
Stephens, Thomas	50	Joyce's Alley	5	1 0
Stephens, Thomas	70	Crooked Alley		2 0
Taylor Francis	62	At the Key		1 6
Taylor, Widow	47	Mayall's Alley	3	4 6
Tomkins, George & Wife	66	Oldbury		3 0
Tovey, Philip	35	Union Alley	5	1 10
Urwell, Ann	54	Mill Bank	1	1 6
Walker, William	71	Merrett's Yard		1 6
Watson, Jervis	29	Well Alley	4	2 0
Watson, Jane	70	Alms Houses		1 6
Webb, Richard	70	St. Mary's Lane		1 0
Wilkes, late Widow chil.		At Gloucester	2	4 0
Wilkes, Widow	60	Crooked Alley		2 0
Wilkinson, Widow	54	O. Meat. House Alley	1	2 0
Wiltshire, Mary	47	Union Alley	3	4 9
Wise, Widow	68	St. Mary's Lane		1 0
Witts, Widow	52	Mr. Moore's Houses	2	2 6
Wood, James	36	Workhouse Alley	4	3 3
Woodward, Robert	43	Joyce's Alley	5	2 0
Woodward, Widows child		Oldbury	2	2 6
Teukins, John		Smith's Lane	1	0
Yarnall, Widow	46	Mayall's Alley	2	4 0
Yarnall, James	40	Yarnall's Alley	6	4 6
Rogers, Widow	67	St. Mary's Lane	1	0

When the number of Children is stated, its is to be understood as those only under 14 Years of Age.

FEMALES WITH BASTARD CHILDREN.

Name	Pay	Name	Pay	Name	Pay
Allen, Elizabeth	2 0	Clay, Elizabeth	6	Harris, Ann (2 children)	4 0
Anderson, Mary	2 0	Clay, Eliz. Jun. (2 chil.)	2 6	Holder, Harriett	1 0
Barrett, Sarah	1 6	Collins, Elizabeth	1 6	Holbrooke, Hannah	1 6
Bedford, Sarah	1 0	Crockett, Ann	2 6	Hook, Mary	1 0
Bishop, Mary	1 0	Davis, Sarah	1 6	Hook, Mary (2nd)	1 0
Bonue, Ann	1 6	Elton, Elizabeth (2 chil.)	4 0	Hook, Mary (4 children)	6 0
Brookes, Ann	1 6	Evans, Ann (2 children)	2 6	Hyatt, Ann (4 children)	6 0
Bubb, Sarah	1 3	Finch, Ann	1 8	Jones, Mary	1 6
Burn, Mary Ann	1 6	Gibbons, Margt. (3 chil.)	5 0	Kinson, Maria	1 6

Name	Pay	Name	Pay	Name	Pay
Lacey, Maria	1 0	Nutty, Eliz. (2 chil.)	3 6	Staite, Ann	2 0
Leach, Temperance	1 6	Oakey, Elizabeth	1 0	Steele, Maria (late)	1 0
Leach, Elizabeth	1 6	Partridge, Sarah	1 0	Tovey, Ann	1 0
Morse, Mary	1 0	Phillips, Mary	1 0	Turnes, Harriett	1 0
Newman, Elizabeth	1 6	Porter, Emma	1 0	Wakefield, Esther	1 6
Nicholls, Mary	1 6	Price, Mary	1 0	Wilkes, Mary	1 6
Nicholls, Hannah	1 6	Rogers, Mary Ann	1 0	Wilkes, Elizabeth	1 6
Nind, Ann	1 0	Rudge, Charlotte	1 0	Woodward, Ann (3 chil.)	4 0

The Director of the Poor request Paymasters to carefully examine the above List, and to afford them all the useful information in their power with respect to the Persons receiving assistance from the Parish Funds.

PEARCE, PRINTER, TEWKESBURY.

The guardians of the Tewkesbury Workhouse published details of those people receiving payments, both on a regular and occasional basis. In June 1832, there were 39 families on the 'regular payments roll', with ages ranging from forty-one to ninety-two years. 'Occasional relief' was given to 126 families.

Tewkesbury's medical practitioners had felt the need for a rural hospital for some time and around 1890, with the aid of public subscriptions, Dr Devereux, a local surgeon, had established a 'one room one bath, one nurse', hospital in the Oldbury. It soon became apparent that this was inadequate and by 1871 enough money had been raised to build a proper hospital. This has now become Graham Court, warden-assisted accommodation for elderly people. The lady in the picture was the Matron; dressed in typical Victorian uniform, she must have presented a formidable and intimidating figure.

Ashchurch Camp. At the outbreak of the Second World War, Aschurch Camp was occupied by the RASC. However, when America joined the fray, their forces 'invaded' Tewkesbury and by late 1943 there were some 2,000 troops in the area. Their kindness to the local children was well known and in this picture a party for the local children was held at the camp, probably in the camp fire station, judging by the equipment.

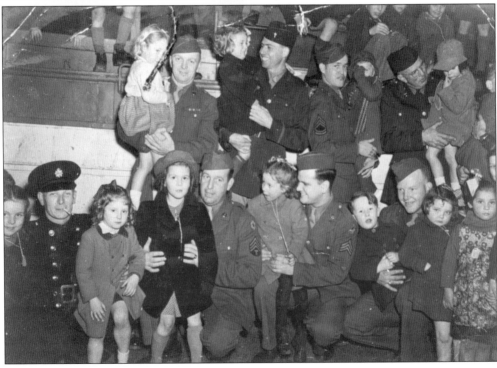

Seven
Education

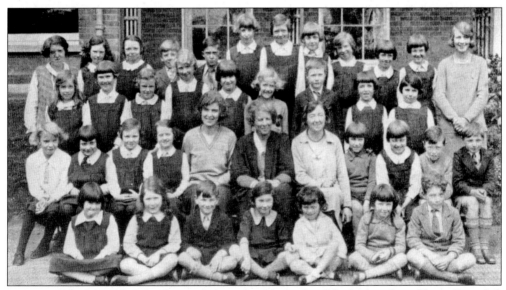

In May 1930, the High School provided a preparatory school for both girls and boys. From left to right: Miss Chamberlain, Miss Kinnison, Miss Holmes (headmistress), Miss Lynn, Mrs Smith.

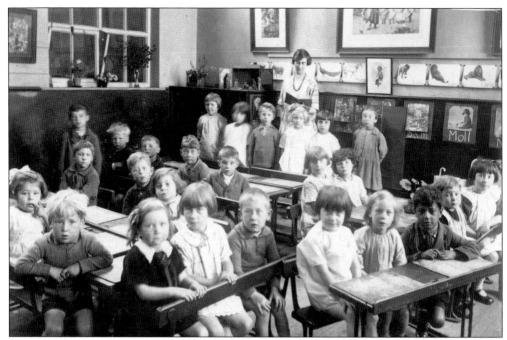

The old Trinity School, with the teacher Gladys Smith at the back of the room, 1920. This was a scene typical in most schools of this period, with religious tracts around the walls. The school survived until the 1970s when improved facilities were made available. At the front desk, third from the right, is a young man who appears to be of coloured origin, most unusual at this time for a small town like Tewkesbury.

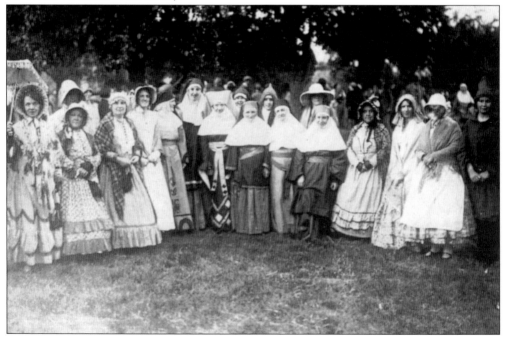

This is part of the Girls' High School Jubilee celebrations held in 1936. The pupils made all their own costumes, with prizes awarded for the most professional-looking.

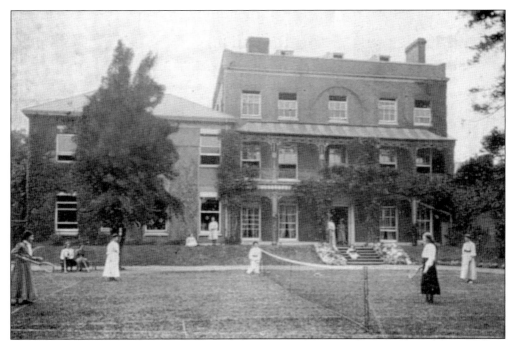

The Girls' High School, 1905. The school was situated in Church Street overlooking the Swilgate Brook and playing field. Boarders were also taken in here, at £8 per term for those under ten years, while day pupils paid £1 8s 6d per term. Extra fees were required for additional subjects: piano was 5s and Swedish drill was 3s 6d per term.

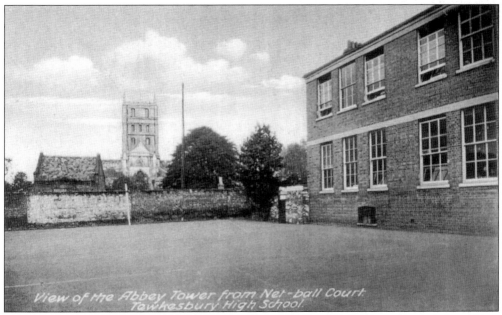

The rear of Tewkesbury High School, with the netball and playing area, and the Abbey looming large in the background, 1930.

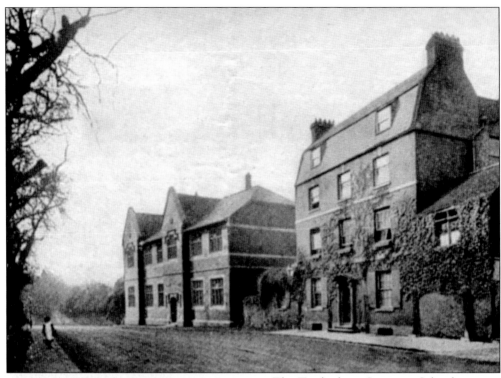

The Tewkesbury Grammar School was originally housed in Abbey House, on the right of this picture of 1905. The school took in boarders as well as day boys and, partly as a result of its success, it needed to expand. The building on the left was built in 1904 to cope with the increase in the number of pupils. Eventually this too became overcrowded and the school moved to Southwick Park.

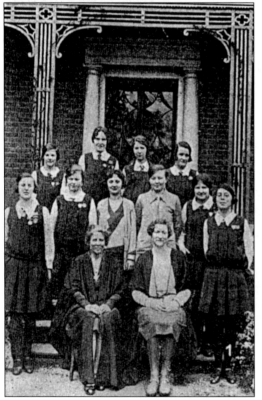

This is the sixth form in 1930, with the headmistress, Miss D. Holmes, on the left and the second mistress, Miss Buckle. A successful school, it provided an excellent all-round education until the comprehensive system took over and this and the Boys' Grammar school were absorbed into the new style of education.

Eight
Alleys

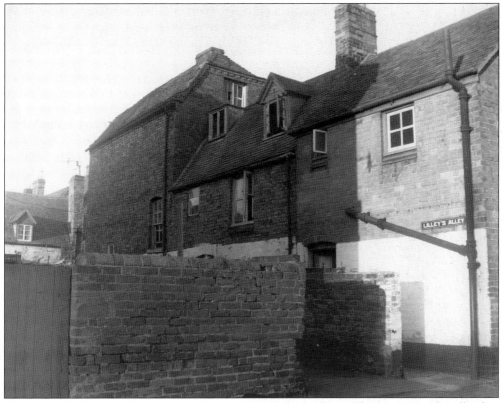

These are the houses which were at the Swilgate end of Lilleys Alley in 1940. The alley has some beautiful half-timbered houses and until recently still had a water pump and stone trough standing there. These properties were demolished in the 1970s to allow the development of flats in this area.

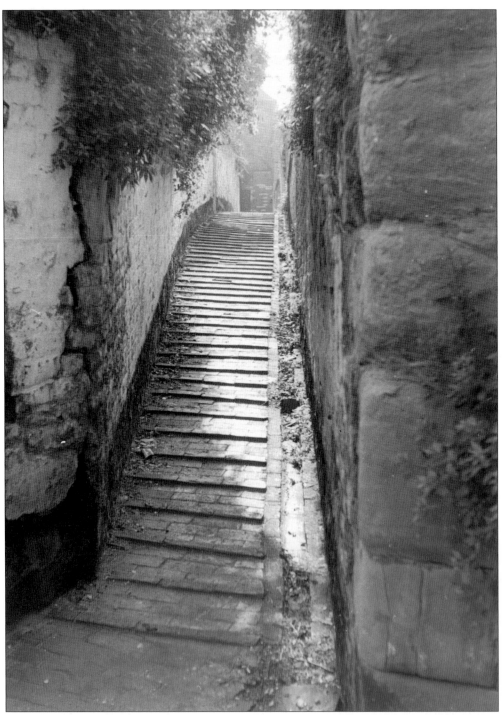

Cares Alley leads from the upper High Street, and falls steeply down to the River Avon. The raised brickwork on the floor facilitated the delivery of goods from the river to the High Street, especially in winter weather. The alley is named after a baker called Cares whose shop fronted onto the main street. This view was taken around 1950.

Lilleys Alley in Church Street, c. 1930. This watercolour of one of the more attractive alleys in the town shows the sixteenth century building, which still remains. Clay pipes were made here and hung out to dry on pipe racks. A hand water pump and stone trough, one of only three left on the town, stood by the corner of this house until fairly recently.

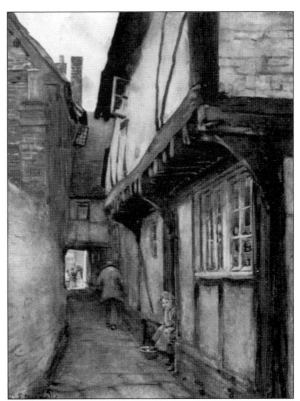

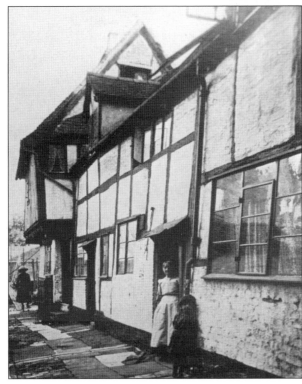

Bedord Court just off the High Street, c. 1925. The alley gives us some indication of the houses which abounded in the town; late fifteenth and sixteenth-century structures were the norm, with the usual overhanging upper storeys.

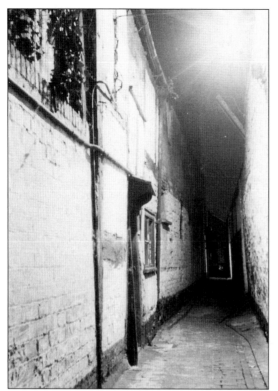

The Barrel public house stood next to Tewkesbury Garage in the High Street. This is the passage which ran along the left-hand side of the pub, and gave access to the bar on the right. Like many of the pubs in the town, it boasted a skittle alley at the rear. The pub was closed in 1965, when this picture was taken, and demolished in 1971.

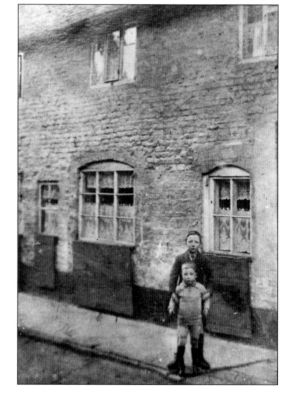

Situated in St Mary's Lane, Coalyard Cottages was a row of terraced houses, demolished around 1930. This shows the row in 1928, with two of the 'tenants', Arthur Healey, at the rear, and his brother, Leonard, outside. The site is now a car park.

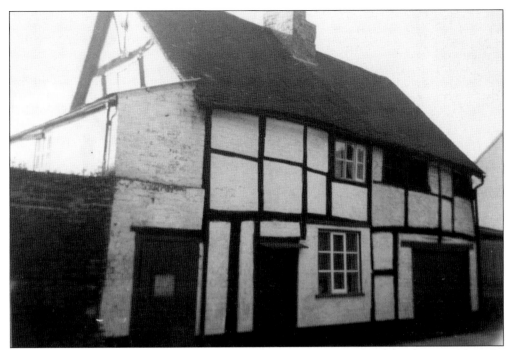

Situated in St Mary's Lane, this was the Tanner's Arms, one of the few pubs not situated on the main streets, *c.* 1960. Here were the tan yards where the leather was treated to provide the numerous boot and shoemakers with their raw materials. The building has hardly changed in the past century.

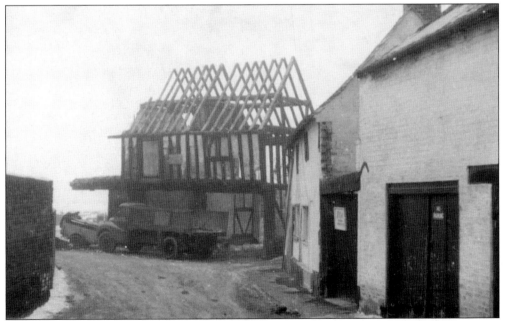

This half-timbered building, Mary's Lane, in the process of being demolished in 1965, had been in use as a garage for some years prior to this date. Its removal made way, together with other properties, for the Hop Pole car park.

Another connection with the John Halifax novel, this building was depicted as the study in which he worked. The building overlooked the Avon from St Mary's Lane.

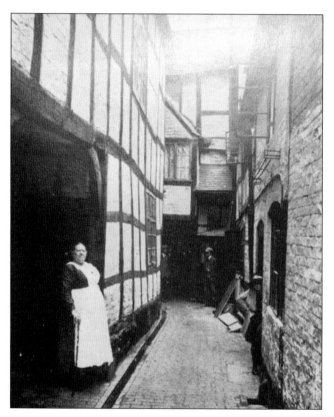

Named after a tailor called Wall, this is the view looking down Wall's Court toward the High Street entrance, c. 1910. The building on the left has been renovated, and the doorway has been bricked over. The young man on the right is standing in the entrance to the Nottingham Arms.

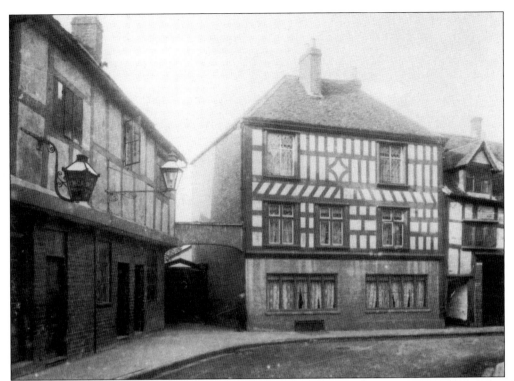

Tolsey Lane, leading from the Cross to the rear of the High Street and thence to the river, c. 1910. This photograph shows how the town was lit by gas. The house on the right, Tolsey Cottage, which has recently been renovated, shows the entrance to Priors Alley. To the rear of these properties were workshops and builders' yards.

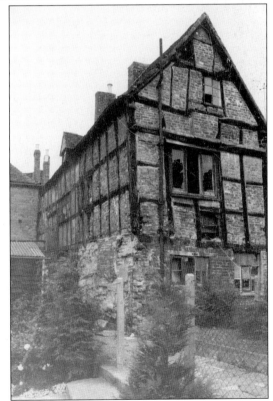

A semi-derelict half-timbered building in Walls Court, off the High Street, 1965. A sixteenth or seventeenth-century house, it was due for demolition when this picture was taken. It was bought and restored by a local trust and was thankfully saved for the future.

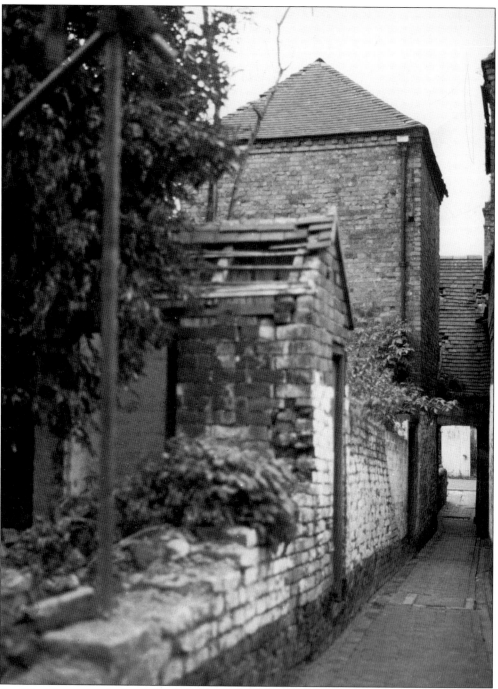

Ancills Alley, named after John Ancill, which ran from Church Street to the Swilgate Road, c. 1970. It was closed off many years ago and is now a court, giving access to the Berkeley Arms. The small building on the left which was a privy serving the families in the alley.

Nine
Transport

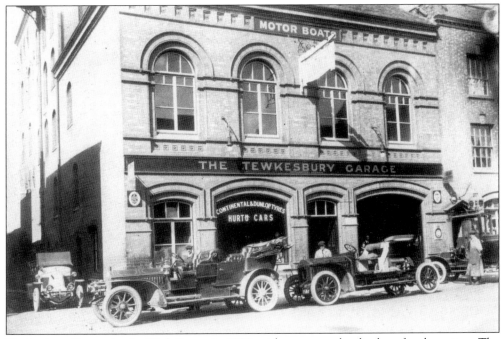

Tewkesbury Garage in the High Street in 1920, with a spectacular display of early motors. The sign at the top of the building also advertises motor boats for sale or hire, an unusual combination. The building at the rear was the Abbey Brewery, and to the right is the Shakespeare Inn.

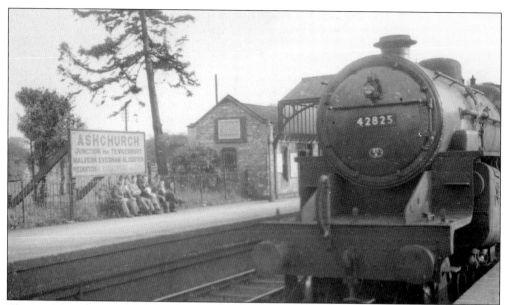

The main line to Birmingham stopped at Ashchurch station until the Beeching axe fell and the station was closed, together with the branch line to Tewkesbury. This photograph was taken around 1940, and the boys on the seat are probably early train spotters. Happily, the Beeching decision was reversed, due mainly to public pressure, and the new station was re-opened in 1998.

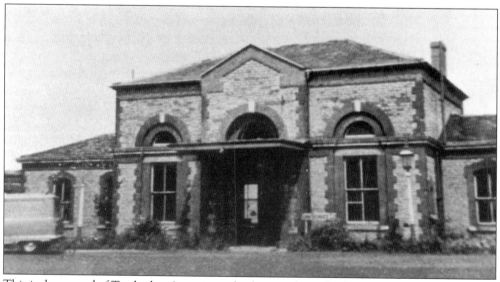

This is the second of Tewkesbury's stations, the first one being built adjacent to the High Street in 1840. This was built just outside the town centre, on a branch line from Ashchurch, including a goods yard and loop into the town and to the mill. After a hundred years or so of useful service, Dr Beeching saw it off.

Tewkesbury's original railway station, built in a gothic design in 1839, fronted the High Street, directly opposite Quay Street. In 1861, however, a branch line was built to Ripple and Malvern, necessitating the transfer of the station away from the town centre. This is the waiting room of the old station around 1870.

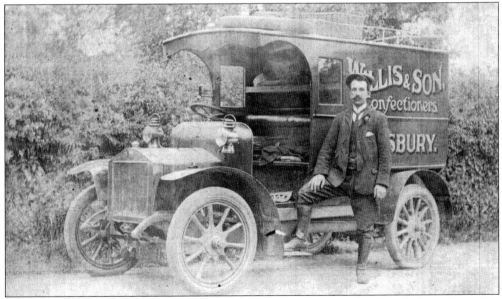

Mr Willis is justifiably proud of his splendid delivery van. His confectioner's shop was at No. 102 Church Street, by the Cross and he delivered his products around the town and also to all the villages in the area. This was at a time when a single item could be ordered and delivered several miles away on the same day!

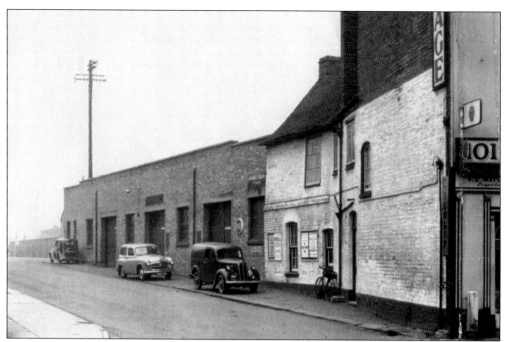

Tewkesbury Car Mart, on the opposite corner of Station Street to the tailors shop, 1964. The workshops ran the full length of Station Street to the Oldbury, with the showrooms fronting the High Street.

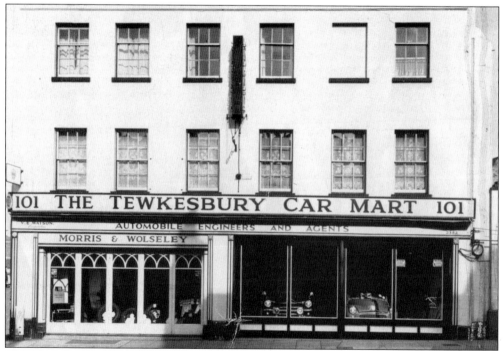

These are the showrooms of the Car Mart, owned by Mr Watson, 1964. To the right of this building stood the first railway station at Tewkesbury, built in 1840. This had a gate, which opened to allow the trains to cross the road and run down to the flourmills and the quay.

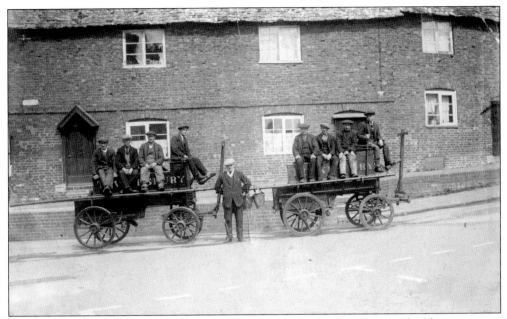

The Tewkesbury Volunteer Fire Brigade in January 1928. The headquarters had been in many locations, including Mill Street, just around the corner from Mill Bank where this photograph was taken. The ladders can be seen lying along the cart with the water buckets hanging down. Mr Cole stands in front, arms akimbo, in charge of the equipment.

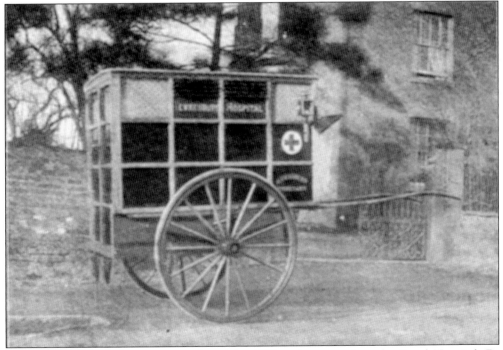

This fine early ambulance was purchased in 1908 and presented to the Rural Hospital. Dr Devereux, a local surgeon, had been the prime mover in setting up the hospital. His wife, together with the Hospital Ball Committee, raised the funds to purchase this vehicle.

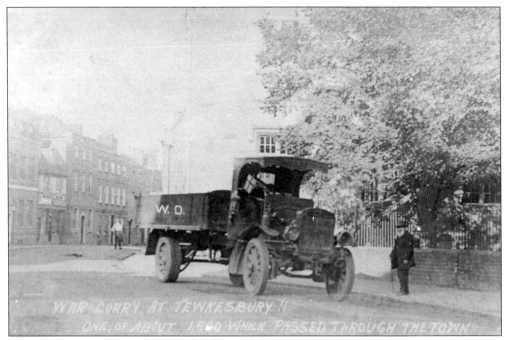

The war came to Tewkesbury in the shape of this Army Truck, one of around 1,500 which passed through the town in 1915. Note the open engine and what look like solid tyres.

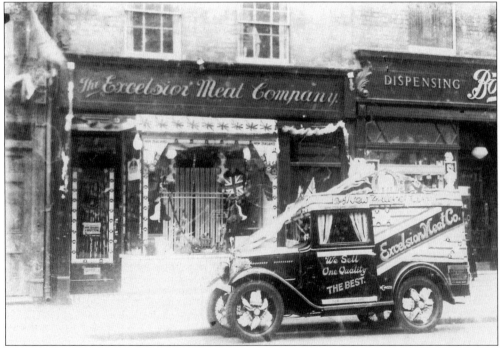

The Excelsior Meat Company store stood at No. 136 High Street. The shop is highly decorated, as it is 1937, the year of the coronation. In the shop window is a model of the royal carriage, whilst the Austin van is festooned with advertisements for New Zealand lamb, even down to the wheels.

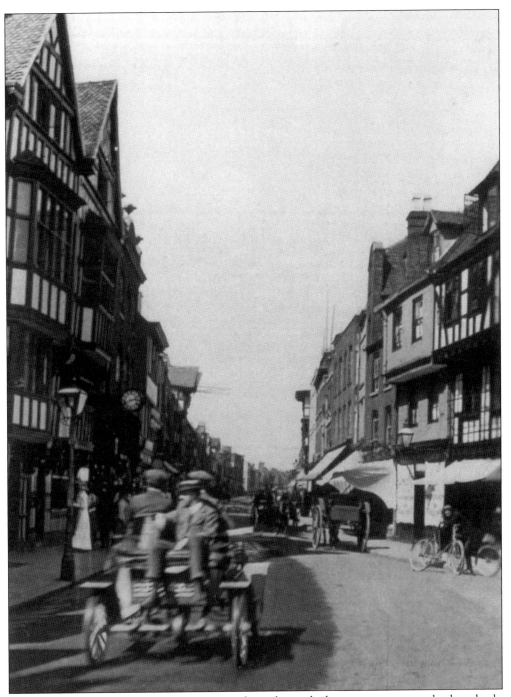

The forerunner of the open-top touring car, this velocipede, known to many as a back-to-back, with what appear to be solid tyres, travels through the town around 1910, with a passenger in the rear seat. Were the horses frightened?

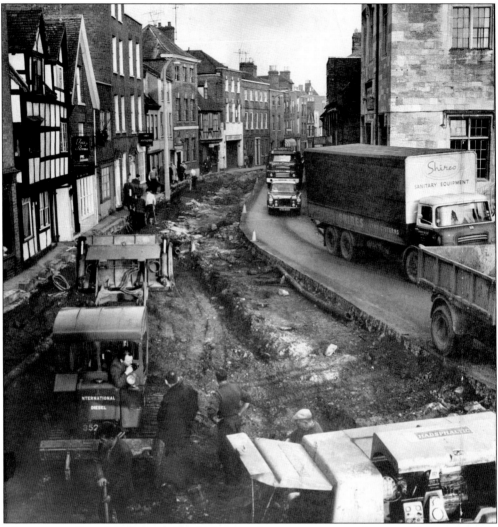

Like most small medieval towns, Tewkesbury, with its narrow streets, has a problem with traffic especially when essential services need replacing. This is Church Street, opposite the Abbey, in 1966, and major works are under way. The work took several weeks to complete and caused great disruption in the town, while a new gas main was being laid.

Ten
Surrounding Villages

Forthampton church, *c.* 1900. Parts of this beautiful building date from the twelfth century.

Twyning Manor, c. 1900. Situated on the outskirts of Tewkesbury, this was a small manor house, built in 1858. During the last war it was used as a boarding school, but in 1976 it was built on and extended, and converted into separate flats, but the main building still retains its charm.

Neighbour Jeynes and his wife Elizabeth celebrated their golden wedding on 15 July 1908. The Jeynes were a well-known family; some of them operated the brick making pits at the Mythe during the mid-1800s. Neighbour lived all his life at Twyning.

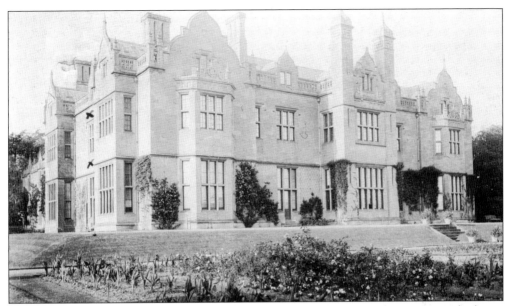

Pull Court situated over the Severn River from Tewkesbury, *c.* 1900. This was once the home of William Tyndale, the translator of the Bible.

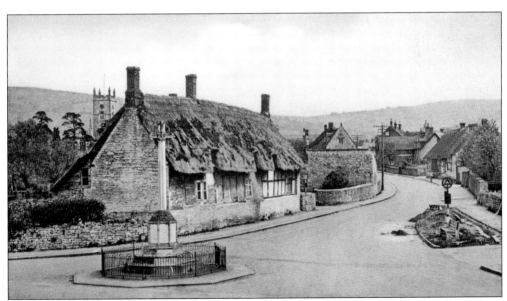

Bishops Cleeve, just a few miles from Tewkesbury, *c.* 1940. This was the centre of the village, with the war memorial at the junction of the roads. In the background stands one of the many thatched cottages in the village, now sadly gone. Around 1960, the war memorial was removed to a site further into the village, to allow for the widening of the road.

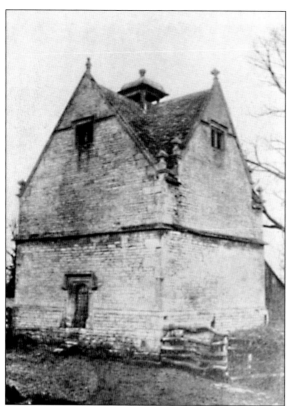

This ancient dovecote at Fiddington, on the outskirts of Tewkesbury, has an inscription on the south face, 'I.I.R. 1637'. Such dovecotes were used to provide food for the owner and his family during the winter months, when food was scarce. This photograph of 1928 shows the building in good repair.

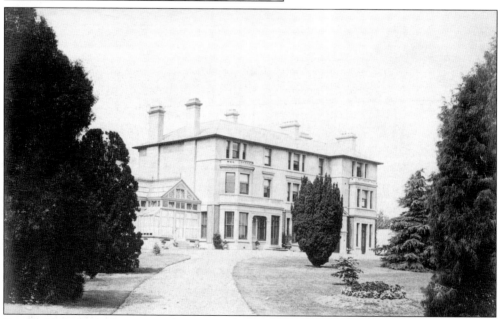

Southwick Park stood in its own large grounds, just off the Gloucester Road. In 1952, the house and part of the grounds became the Tewkesbury Grammar School, which occupy the place for the next twenty years, until comprehensive education took over. This was the house around 1880, when it was a private residence.

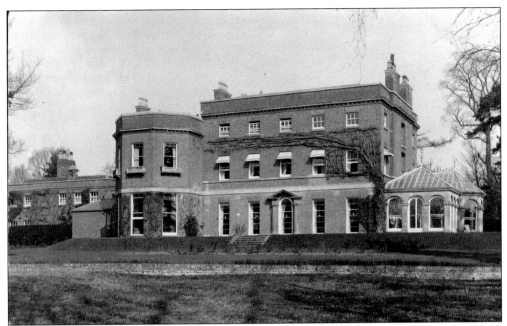

Mythe House, c. 1910. With its position overlooking the town, this was used by the American forces for a short time during the war. It was demolished in 1954.

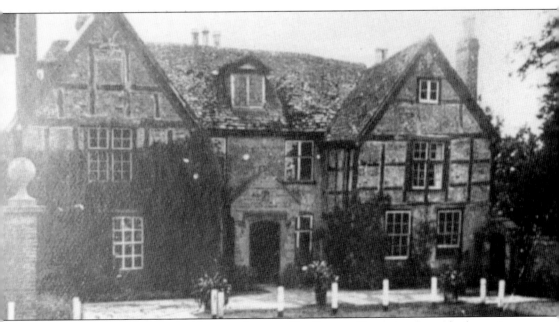

Stated to be one of the oldest buildings in the area, Tredington Court sits alongside the main road through Tredington. When this photograph was taken in 1928, the author Temple Thurston was in residence here.

Coombe Hill, 1930. This is the footbridge built across the Wharf, and is similar to the one in Pagetts Lane, Tewkesbury, and others in the area. It is a feature of Coombe Hill which is no longer in existence. The village was lit by gas, judging by the lamp on the right-hand side of the road.

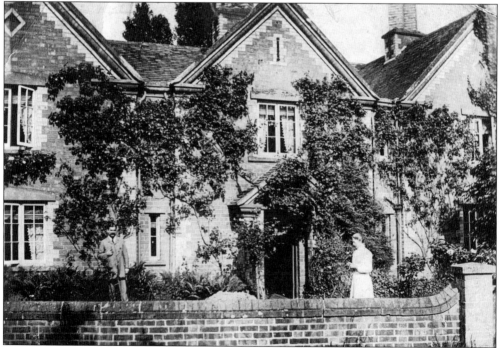

Northway is situated just a couple of miles from Tewkesbury, and this is Northway House in 1928. Tom Hurst and his wife are tending the garden. The whole of Northway has since been densely developed, with both local authority and private housing.

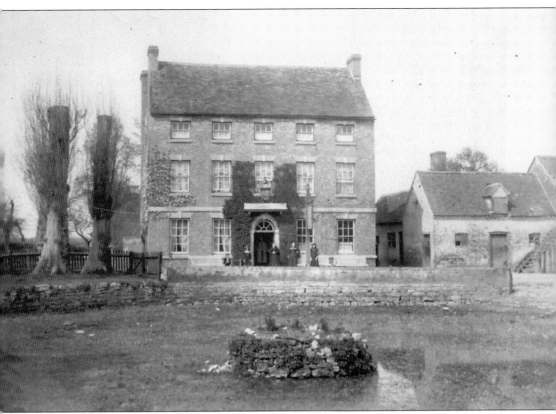

The Tewkesbury photographers, Mallet and Sons, were prolific in their output of views, not only of Tewkesbury and the surrounding area, but of towns all over the country. This is The Green Dragon pub at Corse Lawn, a few miles from Tewkesbury, photographed around 1900. The family poses outside and would find it difficult to recognize the changes which have taken place there in the past one hundred years.

A view up the hill at Cropthorne Village, *c.* 1880, A mixture of fifteenth and sixteenth-century buildings, and later brick structures, make this a most attractive village.

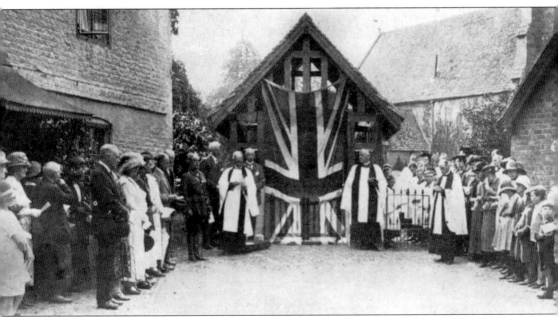

This is the dedication of the war memorial at Beckford, which took place on 30 June 1925. The ceremony was one of thousands across the country, after the end of the First World War. In uniform on the right is Brig General W.F. Bainbridge, with Archdeacon C.H. Ridsdale who took the service.

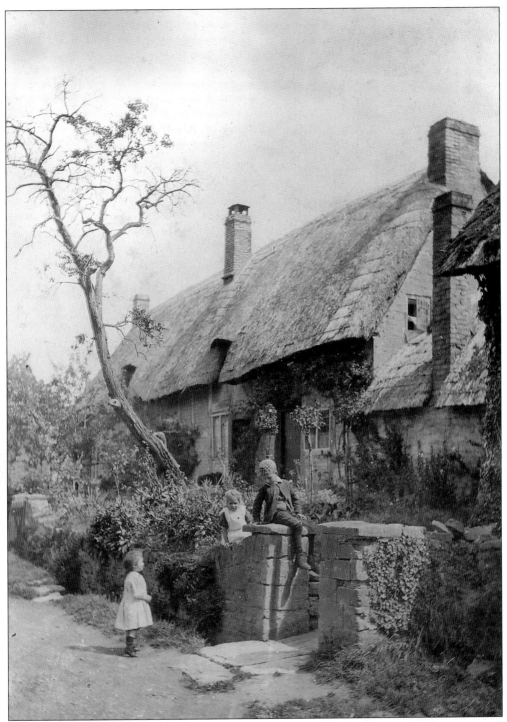

A short distance from Overbury lies the village of Kemerton. One can imagine this as a warm summer's day in the village around 1880. The small boy outside the thatched cottage is dressed in knee breeches and wears a knitted cap, while the little girl outside the gate is wearing typical high-heeled shoes.

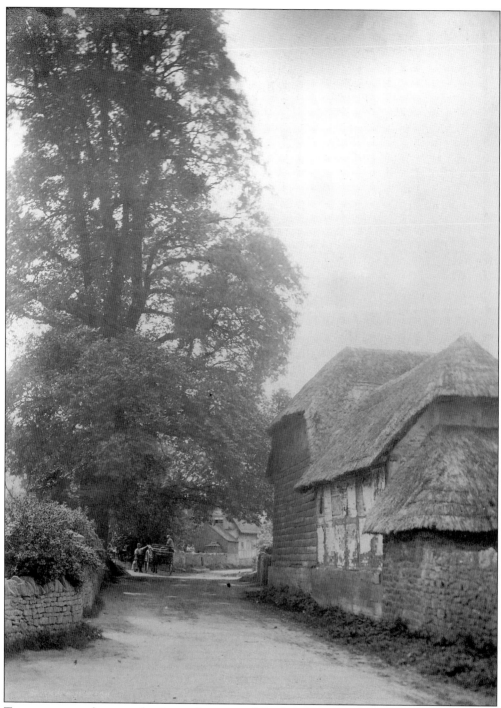

Two enormous elm trees dominate this view of Bredons Norton another picturesque hamlet below Bredon Hill, *c.* 1890. Here we see the unmade road winding through the village. The carter and one of the locals are able to pass the time of day, while the small thatched barn and half-timbered outbuildings standing on the right look as though they have been there forever.

Another of the many lovely villages that nestle under Bredon Hill, just a couple of miles from Tewkesbury. This is the main road from Bredon, and on the left is the village store. A superior building with vertical timbers on the upper floor and the large windows, this may well have been a merchant's house originally. The children and the perambulator help date the photograph to around 1880.

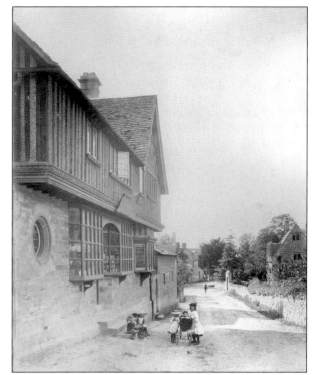

The original Tythe Barn at Bredon, c. 1880. This was an ancient structure, used to store hay and grain, but suffered a fire sometime in the 1970s. Thankfully it was rebuilt at a later date and restored to something like its former glory. The large pile of stones would have been used to repair the tracks and roads, and the steps would have led up to a grain store.

This is the interior of the original barn at the same date. A quite substantial structure as can be seen from the size of the beams, which could have come from a local forest. A chaff cutter and a seed drill are stored inside.

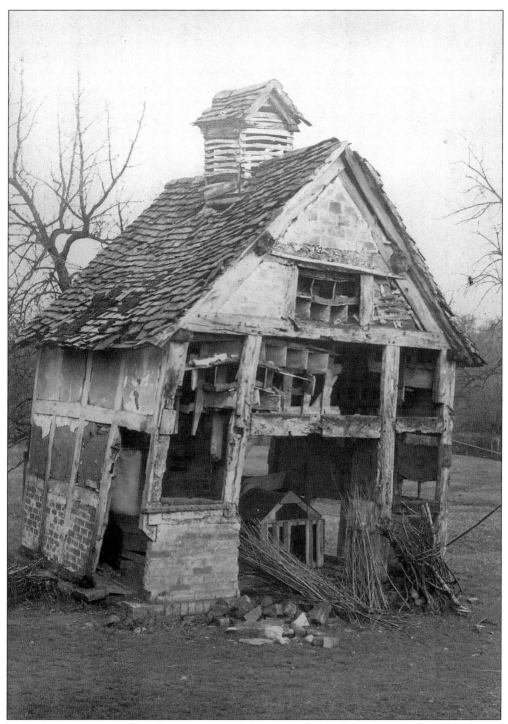

A derelict dovecote at Cropthorne, c. 1880. This was a timbered structure and, unlike most of the others in the area, a substantial building obviously built to last, judging by the size of the timbers. It is used now for storage and perhaps as a rabbit hutch, but is now slightly past its best!

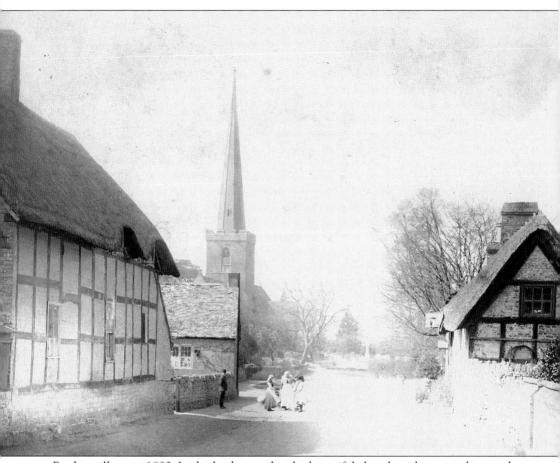

Bredon village, *c.* 1890. In the background is the beautiful church with a spire that can be seen for many miles. This is a quiet village scene with the children able to play in the streets. The dresses and bonnets have not yet been overtaken by modern fashion. Note the quaint globe gas lamp on the Fox and Hounds pub on the right.

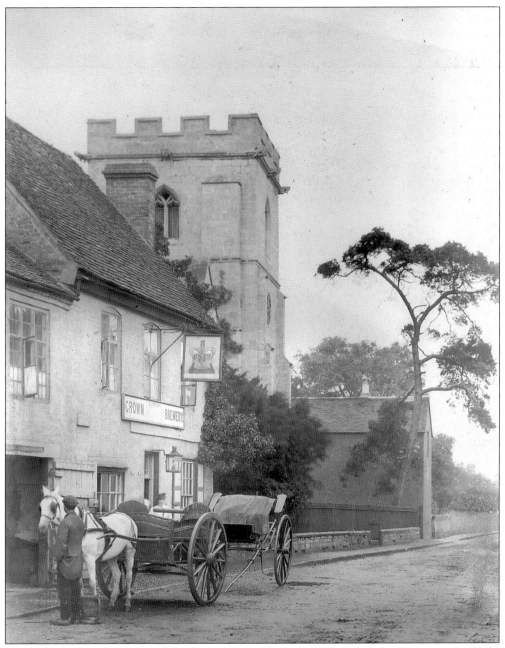

Eckington looking back toward Bredon, *c.* 1880. The pub on the left is the Crown, and it looks like a delivery has just been made. The landlord outside the door is Mr W. Watson, who, according to the notice on the cart, also owns the Crown Brewery.

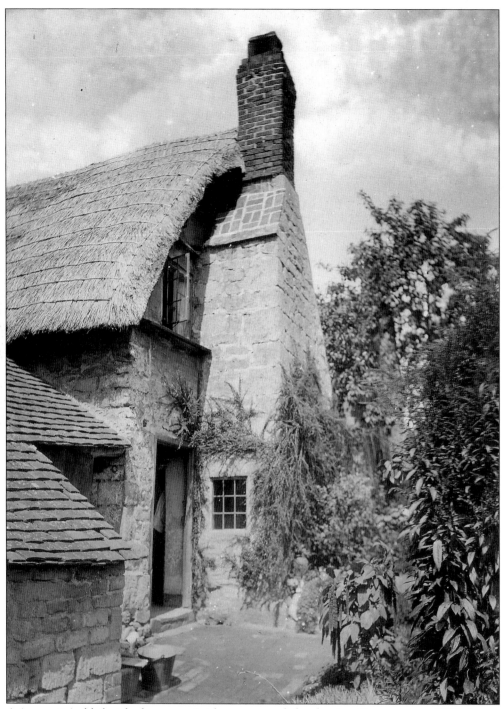

A 'romantic' old thatched cottage, 'with roses round the door' at Kemerton, *c.* 1880. It was possibly a farm worker's cottage with sufficient ground to provide vegetables throughout the year for his family. These properties are now at a premium and much sought after.

126

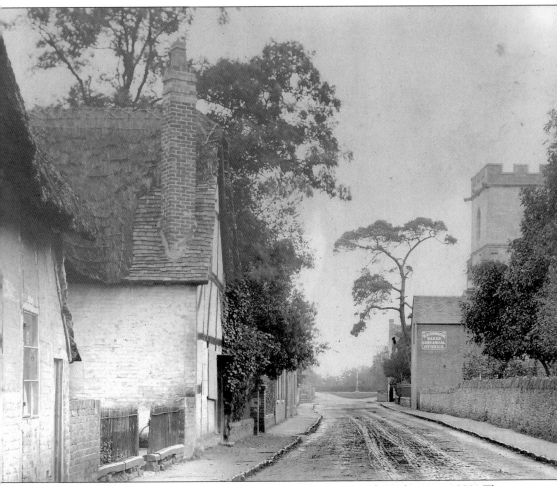

Eckington village showing the main street through to the river and Pershore, *c.* 1880. The church on the right stands next to the Crown public house. In the background, at the road junction, is a piece of land on which the war memorial now stands. The sign on the large building on the right advertises Mr Thornton's Bakery and Corn Meal Stores. The thatched roofs on the left have long since gone.

Part of Bredon church seen from the burial ground, *c.* 1880. The decorated archway above the door has slender columns rising at each side. The wrought iron strapwork on the large door is highly decorative, befitting a church, and is the sort of work the local blacksmith would have undertaken. The early gravestones and monuments carry the history of the village and its people.